BUILD YOUR OWN

PINHOLE CAMERAS

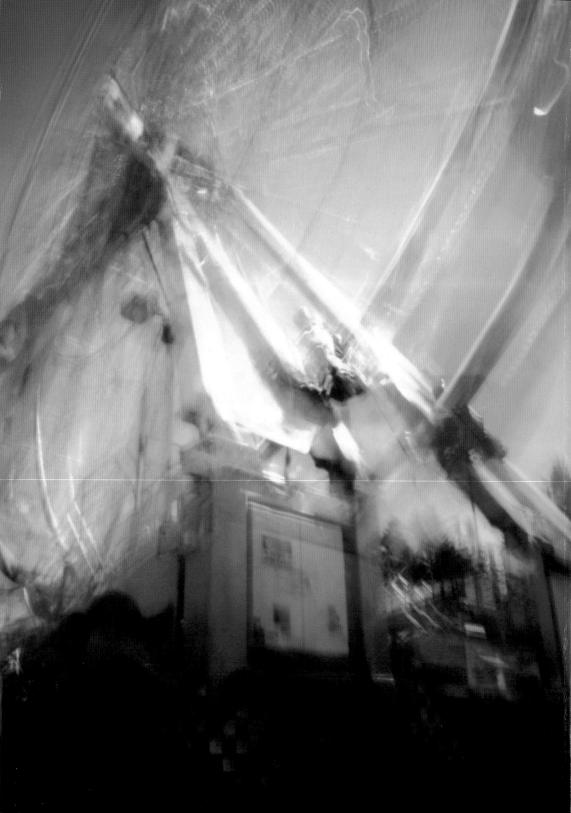

BUILD YOUR OWN

PINHOLE CAMERAS

Print out and make cool paper cameras to take amazing photos

BY

Justin Quinnell

CAMERAS DESIGNED BY

Josh Buczynski

First published in the UK in 2013 by ILEX 210 High Street Lewes East Sussex BN7 2NS www.ilex-press.com

Distributed worldwide (except North America) by Thames & Hudson Ltd., 181A High Holborn, London WC1V 7QX United Kingdom

Distributed in the US and Canada by Ingram Publisher Services

Copyright © 2013 The Ilex Press Limited

PUBLISHER: Alastair Campbell
ASSOCIATE PUBLISHER: Adam Juniper
EXECUTIVE PUBLISHER: Roly Allen
MANAGING EDITOR: Natalia Price-Cabrera

EDITOR: Tara Gallagher

SPECIALIST EDITOR: Frank Gallaugher CREATIVE DIRECTOR: James Hollywell DESIGN MANAGER: Ginny Zeal

DESIGN: JC Lanaway

PICTURE MANAGER: Katie Greenwood

COLOUR ORIGINATION: Ivy Press Reprographics

Any copy of this book issued by the publisher is sold subject to the condition that it shall not by way of trade or otherwise be lent, resold, hired out or otherwise circulated without the publisher's prior consent in any form of binding or cover other than that in which it is published and without a similar condition including these words being imposed on a subsequent purchaser.

British Library Cataloguing-in-Publication Data A catalogue record for this book is available from the British Library.

ISBN: 978-1-78157-992-3

All rights reserved. No part of this publication may be reproduced or used in any form, or by any means – graphic, electronic or mechanical, including photocopying, recording or information storage-and-retrieval systems – without the prior permission of the publisher.

Printed and bound in China. 10 9 8 7 6 5 4 3 2

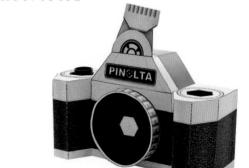

Contents

INTRODUCTION	6-7	Using Your Paper Cameras	52-53
		Color Photography	54-57
The Rebirth of Pinhole		Black-and-white Photography	58–61
Photography	8–9	Loading Your Camera	62-63
What's on the Disk	10-11	Exposure	64–65
Printing Color Templates	12-13	Advanced Exposure	66–67
Coloring Line Art Templates	14-15	Your First Photos	68–69
		Landscape Photography	70-71
Building Your Cameras	16-17	Portrait Photography	72-73
Before You Begin	18–19	Still-life & Close-up Photography	74-75
Making a Pinhole Lens	20-21	Using Flash	76-77
LIKE-A	22-23	Starter Projects	78-81
PINOLTA	24-27		
HOLEIFLEX	28-31	Digital Pinhole	82-83
PINOX	32-35	Digital Pinhole Perfection	84-85
THRILLIUM FOX HOLEBOT	36-41	DSLR Pinhole Lens	86–89
СНОМРҮ	42-45	Using Digital Pinhole Cameras	
STENCIL CAM	46-49	With Flash	90-91
CAMERA OBSCURA	50-51	Digital Pinhole Effect	92-93
(a		FURTHER INFORMATION	94
		INDEX	95

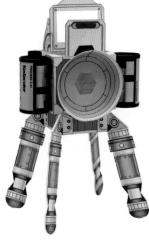

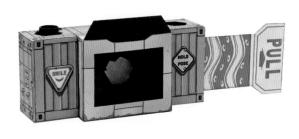

ACKNOWLEDGMENTS

96

Introduction

Since the invention of photography, the medium has evolved an "f/8. 1/125 second, 5 feet off the ground" convention, and while there is nothing wrong with adhering to this approach it can be argued that this predictability removes the element of wonder. This is reinforced in the digital world where the viewer can see exactly what has been photographed the instant the shutter is pressed. All these advances are incredibly useful, but maybe we are too used to seeing these instantaneous miracles that wonder has been replaced by blind expectation?

Pinhole photography is a return to simplicity, combining the image-forming properties of a simple hole with the ability to permanently record the image. It is a radical alternative to conventional photography, which enables you to explore a world beyond the limitations of the human eye, and discover wonder and delight through experimentation—qualities that are now increasingly absent from contemporary photographic practice.

For 20 years, I have been making and using pinhole cameras. These have ranged in size from those that are small enough to fit in my mouth, to those the size of trash cans, or even whole rooms. I have fired them into the air on rockets, thrown them off buildings, held them underwater, and taped them onto trains. The cameras have been exposed for such long periods of time that the emulsion has been eaten by airborne mold, and I've used a wide variety of materials, from

fruit to rain boots, cardboard tubes to chip packages. Although simple in its design, the pinhole camera creates unseen and un-visualized images, and even after 20 years of experimenting with this type of photography, I still encounter surprises with every film processed.

This book is designed to introduce you to the wonder of pinhole photography. The cameras you will build have the potential to create photographs that are impossible to capture with digital compacts, giving you the opportunity to make pictures limited only by your imagination!

The History of Pinhole

Using a tiny hole to form an image is not new-in fact, the earliest man to walk the Earth may well have noticed images being formed on the ground as light was projected through tiny gaps in the leafy canopy of his primeval forest. However, it was not until 400 B.C. that modern notions of image formation through a pinhole began to develop.

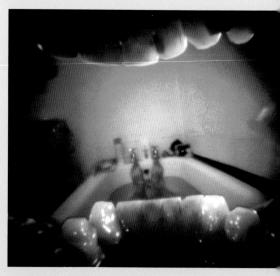

ABOVE: Pinhole photography lets you create images that conventional cameras cannot.

when Chinese philosopher Mo-ti noted that a small hole could be used to form an inverted image, and that the rays of light acted in a similar way to arrows being fired. Around the world, great thinkers all added pieces to the jigsaw of pinhole imaging, with Aristotle (350 B.C.) observing that an image of the sun stayed circular when projected through either a small round hole or a square one, although he came to no conclusion why this was.

Later on, Ibn al-Haitham Al Hazan (1000 A.D.) started to experiment with image formation through a pinhole, while Filippo Di Ser Brunelleschi (1420 A.D.) used the hole to successfully demonstrate one-point perspective, altering the way people portray the world forever.

These early forays led to the development of the camera obscura (or "veiled chamber"), a simple box with a hole in it that allowed an image to be viewed. Initially used for viewing solar eclipses, the camera obscura could be made to virtually any size—from portable boxes used as drawing aids, to purpose-built rooms that became popular tourist attractions at the time.

By the 16th century, simple glass lenses were in production, and while many people still used a small pinhole as an aid to improve their vision, or as a simple microscope, the pinholes initially used in camera obscuras were replaced by brighter (although not sharper) glass lenses. Yet despite the transition from pinhole lenses to glass lenses, the picture that was formed remained a temporary occurrence. Although the light-capturing properties of silver salts were recognized by the 1720s, the ability to record images permanently and find a commercial use for this new discovery had proved elusive. It was only through increasing demands in the areas of pottery and engraving that the sciences of optics and light-sensitive materials combined to give us photography. In 1839, its "invention" was announced to the world.

It was already accepted that glass lenses enabled far shorter exposure times, and the pinhole lens was soon discarded as little more than an interesting physics experiment—left alone to children to explore, while "proper" photographers dusted off their shiny new lenses.

BELOW: Taken with a homemade camera, this abstract image covers a view in excess of 360 degrees.

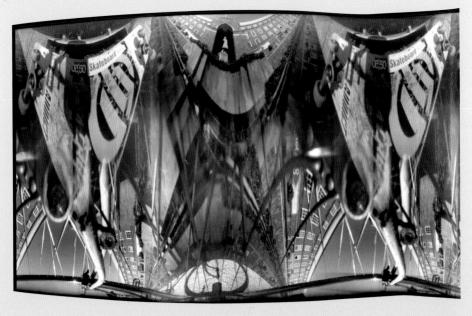

The Rebirth of Pinhole Photography

Although sidelined for many years, a resurgence in pinhole photography's popularity began in the 1970s, continuing throughout the decade and acting as a reaction to an increasingly formulaic approach to photography.

Professionals and amateurs started working by themselves, but encountered reticence from publishers and galleries alike for their unusual pinhole pictures. However, when the Pinhole Resource Center was founded in the 1980s.

pinholers could make contact with like-minded photographers around the world, and the movement slowly gained impetus. With the arrival of the internet. pinhole truly came of age again, providing photographers with a platform to freely discuss and share their experimental pinhole visions, free from the chains of contemporary photography.

Pinhole imaging has now become an essential creative tool—and recognized visual medium—for many artists and students, and a variety of websites, art blogs, and lists provide information of lectures, publications, and exhibitions that surround this creative branch of photography. Its simplicity also embraces environmental and anticonsumerist interests, and acts as a cathartic escape from today's pixel-chasing hunger.

Now, as we charge headlong into the world of digital photography, the properties of a small hole—once seen as a child's novelty—are once again reclaiming their place in our world, almost 2,500 years since Mo-ti first described their imageforming potential.

RIGHT: When you start making your own pinhole cameras you can experiment with extreme distortion effects.

OPPOSITE: A simple pin-sized hole in a piece of metal does things with light that modern glass lenses cannot.

Unique Images from Unique Cameras

Pinhole cameras offer many technical qualities that aren't necessarily easy—or possible—to create using even the most expensive digital SLR. Here are a few of the more obvious qualities, but I am sure you will discover some of your own as you become more confident with the cameras you build.

UNLIMITED DEPTH OF FIELD: Perhaps one of the most incredible features of your paper camera is that everything will be in focus—from objects less than an inch from the pinhole, to distant mountains.

THE ABILITY TO CAPTURE TIME BEYOND VISION: Although your camera can photograph static objects in a similar way to a conventional camera, the tiny hole needs very long exposures. Exposure times will begin at around 2 seconds and can last for hours-you can even make exposures for as long as 6 months!

INDESTRUCTIBILITY AND COST: Several years ago I began sticking cameras onto objects and throwing them off buildings and bridges, using them as shuttlecocks, taping them onto trains, and all sorts of other "unconventional ideas." This resulted in all kinds of haphazard visual adventures. Some were unequivocal failuresmany "lost" cameras are probably still exposing to this very day—but the combination of the cameras' relative indestructibility and the low cost means you can experiment in areas of photography where digital camera owners would fear to tread!

MULTIPLE EXPOSURES: This is an area where many modern digital cameras prevent you from going. However, with pinhole photography, you can take two or more images on top of each other, such as placing a cloud scene over a portrait.

WAITING FOR THE PHOTOS TO BE PROCESSED: Although some people celebrate the fact that digital cameras give instant feedback, it's amazing how your images can change from "experiments" to "the greatest photographs ever taken" while you wait for them to be processed!

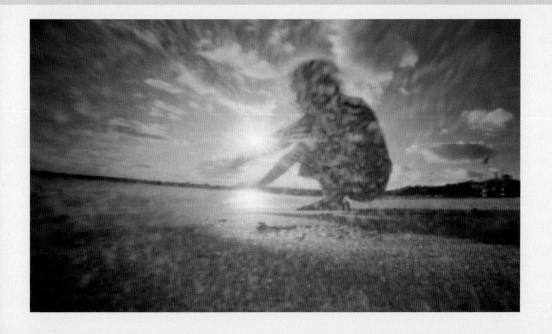

What's on the Disk

The disk on the front of this book contains all the templates you need to make your own paper cameras, as well as a printable exposure guide. The camera templates have been designed so they are ideal for printing at home on your inkjet printer, on Letter or A4-sized paper. There are also blank templates on the disk that you can color yourself—either on your computer, or after printing. We'll look at printing and coloring your templates later in the book, but for now let's take a look at what's on the disk.

Opening the Disk

The opening screen of the disk contains a License Agreement, the Exposure Guide, and a Cameras folder. To make any one of the seven cameras featured in this book, open the Cameras folder.

Inside the Cameras folder you will find folders for each of the seven camera designs—just double-click on the one you want to build.

You'll now have a choice of Letter or A4 paper. These subfolders contain templates that have been designed for printing on either Letter or A4 paper, so make sure you open the right one for your printer.

Inside the paper size folders are a final two folders—Color and Line Art.

These contain the templates themselves, saved as either PDF files (Color) or PSD files (Line Art). If you can't open the PDF files you'll need to download the free program Adobe Reader.

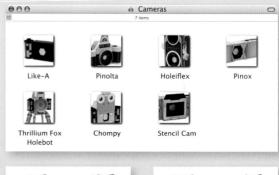

Color Templates

The Color templates for each camera have been saved as a single PDF file, which means you can open it using Adobe Reader (or a similar program) and print out all of the pages you need to build the camera.

Adobe Reader is installed with most operating systems, but if you don't have it on your computer (or a program that will read PDF files) you can download it for free from www.adobe.com. We'll look at how to print color templates on the following pages.

Line Art Templates

The Line Art templates are saved as individual PSD files—rather than a single PDF file-which can be opened using a wide range of imageediting programs, including Adobe Photoshop, Photoshop Elements, and Corel Paintshop Pro. If you don't already have software on your computer that will open the PSD files, you can download a trial version of any of these programs. Alternatively, you can download a free image-editing program called Gimp from www.gimp.org, which is perfect for working on your camera.

Depending on the camera you've chosen there could be several files to open and you need to open and color them all for each camera. Certain parts are already colored black and you shouldn't re-color these bits as they need to be black to make the camera light-tight.

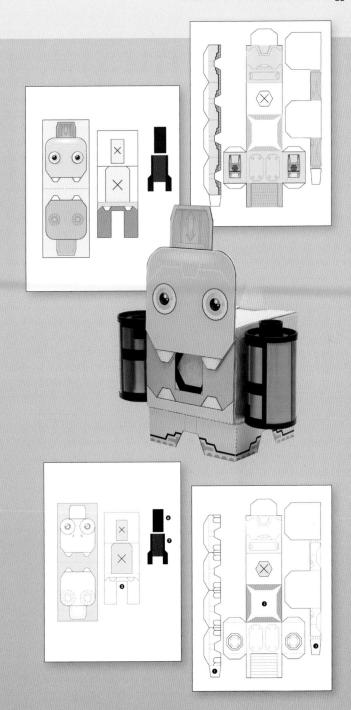

Printing Color Templates

All of the cameras in this book have been supplied as pre-colored templates on the disk, so all you need to do is open the color PDF file for your chosen camera, and print it out. The PDF template file contains all the pages you need to build one camera, which could be anything from a page to four pages, so before you start printing, make sure you have enough card to print all the pages. If you do, then use the following steps to guide you through the printing process.

Page Setup

The color templates have been sized to fit either Letter or A4 paper, and it's important that you check your printer's settings to make sure the pages print properly. In Adobe Reader, choose File > Page Setup from the top menu to open the Page Setup dialog window.

Select your printer from the drop-down Format For menu.

The Paper Size should match the paper in your printer and the template size, so choose Letter or A4 depending on the paper you're using. If there is a Borderless option, choose this.

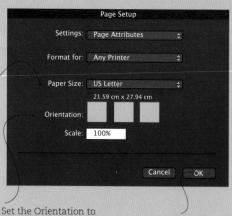

portrait (upright) to match the template, and set the Scale to 100%. You may find both of these are already set.

Click OK to confirm and exit the Page Setup dialog.

Print

Printers use a dialog window called a "driver" to control them, and every manufacturer uses a different system. The accompanying illustration is for a Canon printer, so your printer driver might look a bit different. However, all of the settings we'll be changing can be found in every printer driver-if you can't find them, take a look in the printer's manual or help file on your computer. To access the Print window, choose File > Print from the Adobe Reader top menu. The following settings are the ones you need to find and check:

PRINT ALL: Make sure you are printing all of the pages in the template, not just the current one, or a selection.

PAGE SCALING: If you set your printer to Fit then the template will fit perfectly on the page. This means that none of the pieces on the template will be cut off by your printer.

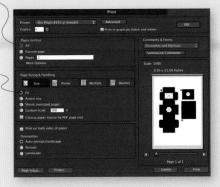

If prompted to set the media type, set it to Plain Paper if you are using plain card stock that isn't specifically designed for inkjet printers. This will stop you using too much ink when you print the template.

If you are using a more expensive inkjet card, then check on the box what you should set your printer to.

Providing that you set these three options you should be ready to print, so press Print and your template(s) should be ready for you to construct your first paper camera.

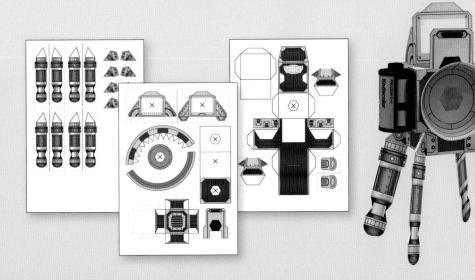

Coloring Line Art Templates

The Line Art folder on the disk contains a set of blank templates for every camera. These are designed for you to color on your computer (although you could print them out and use pens, pencils, or paint). The following tips and tricks will help get you started.

Simple Fill

The Line Art templates come in the form of PSD files, and most of the cameras use more than one file—you need to color and print them all to make a whole camera! I'm using Photoshop here, but you can use Photoshop Elements, Paintshop Pro, or even Gimp to color your cameras. Be aware that some of the tools might be called a different name.

Open all of the pages for your chosen camera in your editing program, then open the Lavers palette (choose Window > Layers from the main menu in Photoshop).

> The camera files are supplied as three separate layers—the top one is the outline of the pieces with dotted fold lines (called Outline) and the bottom one is a plain white background. Click on the Outline layer as this is the one you want to color.

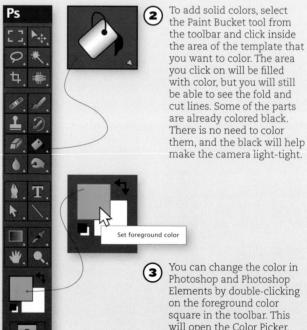

You can change the color in Photoshop and Photoshop Elements by double-clicking on the foreground color square in the toolbar. This will open the Color Picker, where you can click to choose a different color for the Paint Bucket tool to use.

Keep changing colors and filling the areas of the template until you are done. Remember to color all the pages before printing them out using the instructions on the previous pages!

The Brush Tool

Although the Paint Bucket tool is a great way of quickly coloring a template, it limits you to flat blocks of color. For some cameras this might be all you want, but if you reach for the Brush tool you can start getting a little more creative.

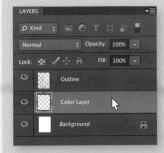

As before, open the template and the Layers palette. Click to highlight the Background layer then select Layer > New Layer

from the main menu. Call this new layer "Color Layer"—this is the layer you will be painting into.

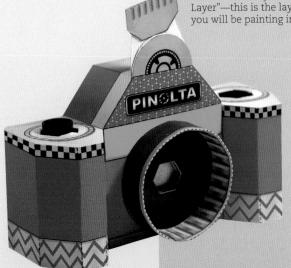

Pick the Brush tool from the toolbar and start work. The Brush tool works just like a paintbrush. Your editing program will let you change the size, shape, and hardness of the brush, and you can change the paint color by changing the foreground color as before. Some programs also let you use shapes instead of a round brush to add diamonds, hearts, lightning shapes, and similar.

With the Brush tool, you can paint your template "freehand," and use different colors to create patterns or shapes. Don't worry if you go outside the lines of the template with the Brush—when you've printed your template you will cut these areas out to make your camera.

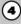

Keep painting the template until you're done, remembering to paint all the pages for the camera before printing it out and building your own unique camera, like this colored version of the Pinolta.

Building your Cameras

We've seen how to print out the camera templates, and how to color them (if you want to), so now it's time to see how to make them. This chapter shows you how to make everything from the most simple pinhole camera through to the most sophisticated.

The most basic camera is the Like-A, which is also the starting point for all of the other cameras on the disk. So whether you want to keep things nice and easy to start with, or build one of the funkier cameras, the Like-A on page 22 is the place to begin. But before you jump straight in, read through the following pages where you'll find out what tools you'll need, pick up a few tips and tricks when it comes to putting together the camera templates, and discover how to make the all-important pinhole lens that can be the difference between great pictures and less impressive ones!

Before You Begin

Making paper cameras is very easy, but you'll need a few tools to manufacture the pinhole lens and the cameras. Don't worry though, there are no specialty items and you will probably already have most of the things you need. Making a pinhole lens is covered on the following pages, so here we'll concentrate on constructing the cameras themselves.

Gard

- To build the best paper cameras, use a card stock that weighs 135lb (220gsm)—this will work perfectly in your inkjet printer. Avoid using thinner card, as its lighter weight will mean you could have problems making your camera light-tight.
- Heavier card (such as card from a cereal box) can be used to make the basic Like-A model if you don't want to put it into one of the camera shells, and it will make your camera more lighttight. However, your printer will struggle to print on card that is this thick, so print the template onto regular copy paper first and then glue it to the thicker card.

Cutting

- Straight lines are best cut with a sharp modeling or craft knife; use a metal rule to keep the lines straight.
- A rubberized cutting mat will help keep your blade sharp and prevent you damaging your work surface.
- For curved lines, a pair of long-bladed scissors will be very useful, while smaller craft scissors might make it easier to cut out smaller curves.

Folding

- The easiest way to fold the card templates is to score the fold lines first. Use a straight edge—like a metal rule—and the back of a craft knife (not the blade!) or an empty ballpoint pen to "dent" the fold line. Then fold the card according to the key (see above).

Glues and Adhesives

- "Stick type" glues work well with the recommended card stock, or you can use a white PVA glue. Anything that's designed to stick paper and card will be fine, but it will help to speed things up if it's fast drying.
- Double-sided sticky tape can be used for larger parts, but it sticks instantly so make sure everything's lined up-there are no second chances!

Template Key

The templates are designed so the lines on the various pieces act as cutting and folding guides. Make sure you fold things in the right direction as it will make the camera instructions much easier to follow—fold something the wrong way and it will seem as though nothing fits!

CUT (SOLID LINE, BLACK OR GRAY) Cut out the template along

this line.

CUT A SLIT (SOLID LINE, THICK BLUE)

A strong, blue line shows where you should cut a slit or opening on the template to make a tab to close the camera.

MOUNTAIN FOLD (DOTTED LINE)

Mountain folds are the most common type of fold used in the camera templates. Score the line and fold the parts either side of the line downward, so the fold forms a ridge—like a mountain.

VALLEY FOLD (SOLID LINE, RED)

This indicates a "valley" fold. Score the line and fold the parts either side of the line upward, so the fold forms a "valley."

CUT OUT SHAPE

Shapes marked with an X-such as shutter holes—should be cut out from the template.

COLOR (SOLID BLACK AREAS)

Areas of the template that are colored in solid black need to be light-tight so light doesn't creep in and pre-expose, or "fog" your film. Although they are printed black, you should also color the reverse side of these parts with a thick black marker pen or Sharpie to make sure the card is light-tight.

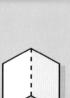

Making a Pinhole Lens

All of the cameras you can make in this book have the simplest form of lens that you can use to take pictures—a "pinhole" lens. It would be easy to see the name and think that all you need to do is poke a pin through the card in the front of the design, but this wouldn't work. To create sharp images. the lens needs to be made out of metal, which lets you create the smallest and finest "pinhole" to take your pictures with.

Making the lens

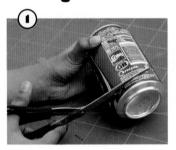

Empty your can and wash it out. Cut one end off the can with your scissors, then cut down the length of the can and remove the opposite end so you've got a sheet of aluminum to make your lens from. Curl the metal flat on the edge of a table, or leave it overnight under a few heavy books to flatten it out. This will make it easier to work with.

It's a good idea to make several "lenses" from your aluminum sheet and choose the best one, so repeat the following steps a few times. Start by cutting out a square from your aluminum, roughly 1½-inch (4cm) square. This will be your lens.

WHAT YOU NEED

- An empty aluminum drink can
- Heavy duty scissors (or similar) to cut the can
- 1200 grit (or very fine) emery paper, also known as "wet and dry" sandpaper
- An eraser approximately 1-inch square (2.5cm)
- A narrow, sharp needle or pin

WARNING

You need to be very careful with the following steps, as you're going to cut open the can. The metal edges you will be left with are going to be VERY sharp, so take care!

The traditional method mentioned in many pinhole photography books is to use a brass shim and hammer it onto a small ballbearing. Personally, I am a great advocate of hammering everything in sight (along with all the noise and destructive fun that goes with this process!), but this doesn't make the best pinhole. More importantly, brass shim isn't something any of my local stores sell.

But they do, however, sell aluminum shim in the form of soda (or beer) cans, which works just as well, and costs a lot less. Plus, I get to enjoy the contents of the can first! You can check the can is aluminum by using a magnet. If your can's magnetic then it's steel (very hard and sharp), and you will need to buy another drink until you find one that is aluminum. With applied carelessness this can take several attempts!

Using your emery paper, sand off the paint from the painted side of the can. You don't need to do it all, just a small patch in the center where your hole will be made. Turn the can over and repeat the process on the other side to remove the thin layer of plastic on the inside and to reduce the thickness of the aluminum.

Put your thinned aluminum lens panel painted-side down on an eraser, and get your needle. Gently press it against the metal and use a drilling action to start making your hole. Keep drilling until the tip of the pin goes through the metal. Only the very point of the pin should puncture the aluminum.

Hold your lens up to a light to see the hole you've made. If this is your first attempt, and the pin went all the way through (not just the tip), then it is probably too big. But don't worry—there's plenty of aluminum left on your sheet, so have another go!

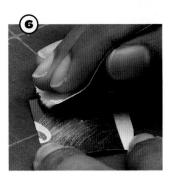

Once you have your "perfect" hole, place the metal paintedside up, and use your emery paper in a circular motion to flatten off the slightly rough bump left by the pin coming through the metal. The hole will probably get filled up with dust, so blow it and hold it up to the light. You should now have a perfect pinhole lens, ready to use in a camera.

Measuring Your Pinhole Lens

The smallest practical pinhole size for your paper cameras is around o.o1 inches (0.18mm)any smaller than this and diffraction (the way the light spreads as it comes through the hole) will counter any increase in image quality. For those who worry about this kind of thing, a pinhole lens of this size would give an aperture of f/120 using the paper pinhole cameras in this book

The easiest way of measuring your pinhole is to hold it flat behind a ruler. Hold the lens and ruler up to a light and, using a magnifying glass (this is a bit of a juggling act), judge how many times the diameter of the hole would fit into one of the smallest measurements on the rule (16ths of an inch, for example). If your hole would fit into a single gap 6 times, then the pinhole lens is about right.

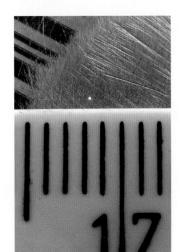

Like-A

The Like-A camera is the most basic camera model in this book, and the easiest to make. But don't let its simplicity fool you—this light-tight box will have you taking great pinhole pictures in next to no time. The Like-A is also the starting point for the other cameras in this book—so why not make a few?

WHAT YOU NEED

- I sheet of card (135lb / 220gsm)
- Craft knife
- Metal rule
- Pinhole lens (see page 20)
- Glue
- Black marker pen

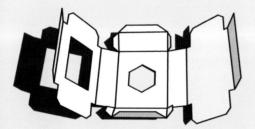

Cut, score, and fold all the pieces as marked, using the key on page 19 as a guide. Remove all the shapes that are marked with an "X."

Unless you are using cereal box card (see Tip section), color the back of the camera black to make sure it is as light-tight as possible.

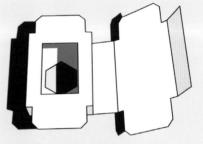

Get some card packaging that is thick enough so that no light can get through—the card from a cereal box is perfect—and glue the front light blocker to it, as well as the internal light blocker (with the black side showing).

Once the glue has dried, precisely cut out the three template shapes and remove the hexagonal hole from the internal light blocker.

TIP

If you're not planning on putting your Like-A in one of the shells, print the template onto regular copy paper and glue it onto card from a cereal box. It will make the camera stronger-and decorated!-and help make sure it's light-tight, so your film isn't fogged before it's exposed.

Next, glue the bottom of the back panel to the bottom of the camera.

Do not glue the top flap so you can open the back to load your film.

Get your pinhole lens and use four tiny dabs of glue to stick it to the front of the camera. This is a temporary bond since most glue won't stick well to aluminum.

(5

To permanently fix the pinhole lens to the camera body, glue the pinhole plate cover (2) to the front of the camera.

The camera is finished and can be loaded with film and readied for taking photographs; just use a piece of black electrical tape over the pinhole lens as a shutter, fit the "camera cape" (3), and turn to page 52 if you want to get started right away. Or, you can build one of the shells on the following pages.

WHAT YOU NEED

- A loaded Like-A camera
- Two sheets of card (135lb / 220gsm)
- Craft knife
- Metal ruler
- Pinhole lens (see page 20)
- Glue
- Black marker pen

Pinolta

The Pinolta transforms the basic Like-A, turning it from a functional black pinhole box into an SLR-style paper camera, complete with a working shutter mechanism and a lens hood!

Assembling the Camera Body

Print out the Pinolta template pages and cut out, score, and fold all of the pieces.

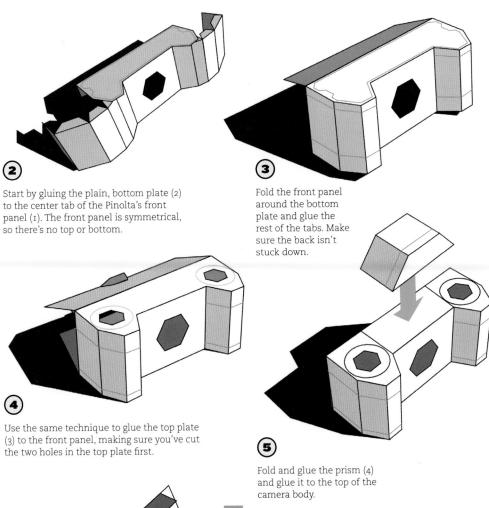

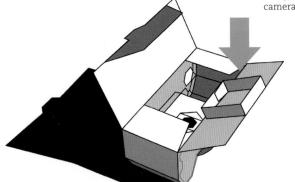

Glue the spacer (8) to form a square. Stick this to the inside of the large tab of the bottom panel. This will keep the Like-A pressed against the front of the Pinolta camera body and prevent it from moving around.

Assembling the Shutter

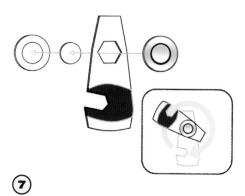

Color the reverse side of the black area of the lever arm (12) to keep light out of the pinhole camera, then assemble the shutter lever using the front disk (9), the disk axle (10), and the back disk (11). Be sure that the notch in the lever arm faces left.

Carefully rotate the joint for one or two minutes to make sure that excess glue does not spread out and permanently seize the rotational movement.

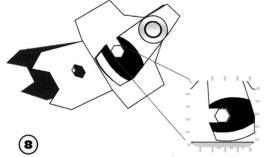

Glue the completed shutter lever to the shutter case (13) on the inside of the front face.

Make sure that you glue it into position so that the arm's notch is centered over the front hole in the "open" position.

the Pinolta camera body.

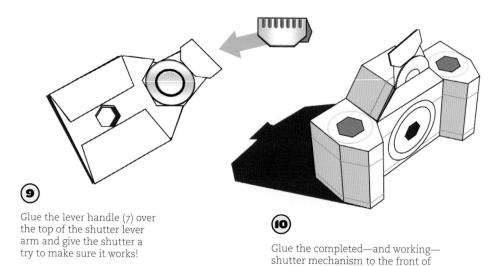

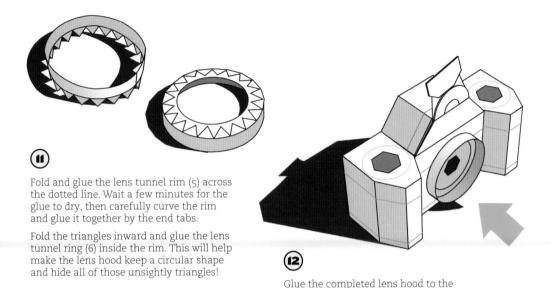

Using the Pinolta

To load the Pinolta, open the back of the camera and insert your loaded Like-A (without the camera cape or tape shutter fitted) with the pinhole lens facing the front of the Pinolta.

When you want to make an exposure, all you need to do is move the shutter arm from "closed" to "open." When the exposure time is up, simply close the shutter. Wind the film to the next frame using a large paper clip in the take-up spool, and turning it three-quarters of a turn counterclockwise.

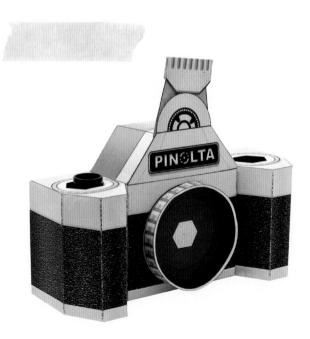

front of the Pinolta camera body.

Holeiflex

The Holeiflex takes its lead from the classic TLR (twin lens reflex) cameras of the 1950s and '60s. This is the biggest paper camera you can make, with working winding knobs and a viewfinder assembly that will give you an idea of what it is you are pointing the camera at.

- A loaded Like-A camera
- 4 sheets of card (135lb / 220gsm)
- Craft knife
- Metal ruler
- Pinhole lens (see page 20)
- Glue
- Black marker pen

Print out the four template pages, making sure you remove shapes marked with an "X." Score and fold all the parts.

You need to make two winding knobs-one to advance the film, and one to rewind it. The assembly of both is identical.

but make sure you cut out the narrow slits in both the inner winding knob (2) and outer winding knob (5) before assembling them.

The winding knobs are made by folding them into an octagon and gluing the end tab.

While they dry, glue a small winding disk (10) to a large winding disk (9) and let them dry for a few

minutes. Position the smaller disk inside the hexagonal hole on the side of the camera body (1) and glue the bottom of the inner winding knob to the small disk as it sticks through the hole.

After a minute of drying, give the knob a light twist to test it and prevent any glue from seizing the joint.

Slide the outer winding knob over the inner winding knob (advance at the top, rewind at the bottom), making sure you line up the slots. Repeat the process to make the second winding knob.

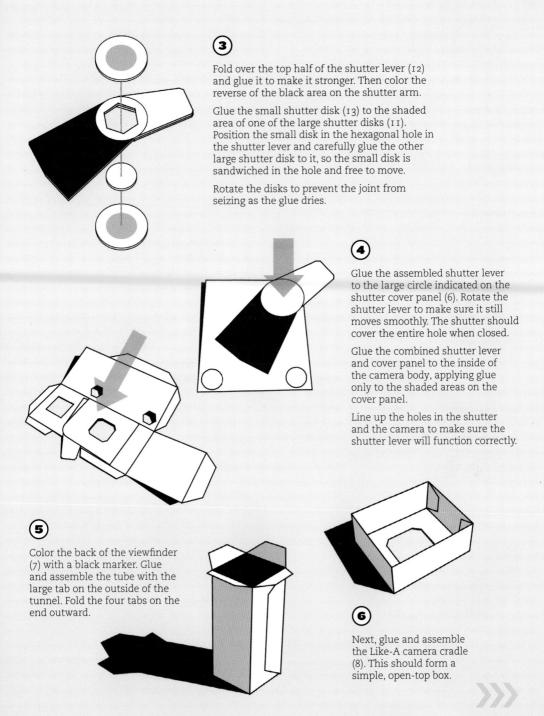

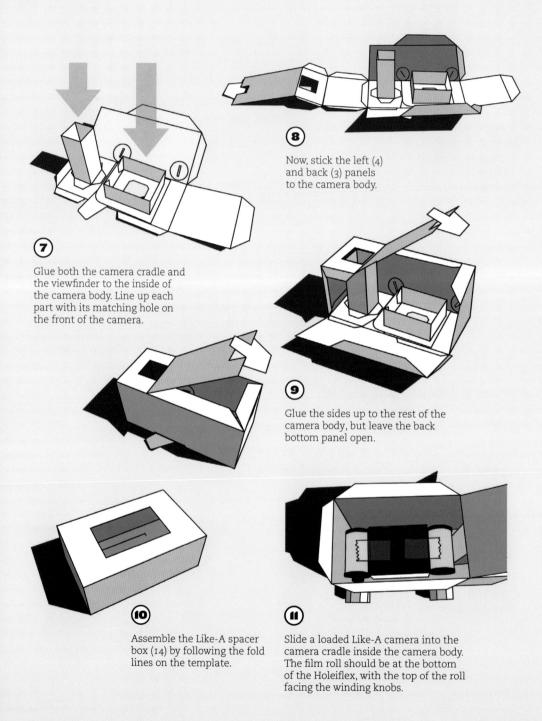

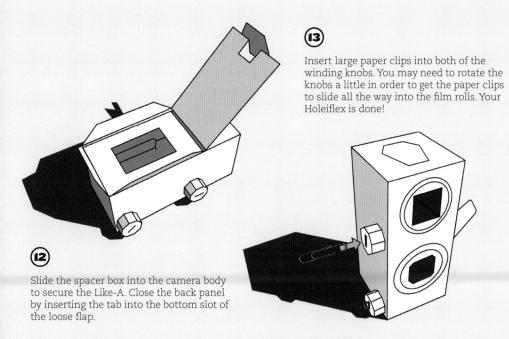

Using the Holeiflex

To start using the Holeiflex, advance the film oneand-a-half turns to get it ready for your first picture.

Aim the camera using the viewfinder tunnel, but note that the angle of view is not the same as the viewing angle of the lens—it is just a guide so you can see where the camera's pointing.

Open the shutter using the shutter lever to expose the film, consulting the paper camera exposure chart to see how long you should keep it open. Once you've made your exposure, close the shutter and wind the top winding knob (the "advance" knob) three-quarters of a turn to advance the film to the next frame.

When you have finished your film, use the bottom (rewind) knob to wind the film back into the cassette, take out your Like-A, and remove the film for processing.

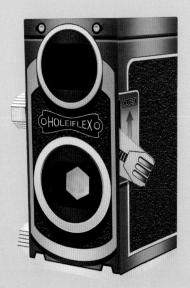

WHAT YOU NEED

- Two sheets of card (135lb / 220gsm)
- One sheet of thick card (cereal box card, or similar)
- Craft knife
- Metal ruler
- Pinhole lens (see page 20)
- Glue
- Black marker pen

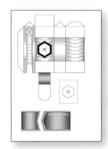

Pinox

With its minimal sliding shell, the Pinox is a sliding spy-style camera for the pinhole photographer. Its simple shapes also make it a great camera for customizingmaybe to help make it blend in with its surroundings so people are totally unaware you are taking pictures?

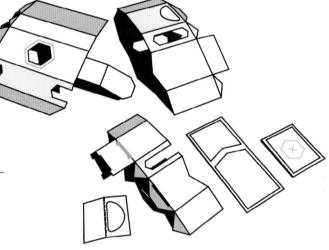

Print the template pages out, and cut out the internal light blocker (2) and the front light blocker faces (3 and 4). Do not cut to the edges of the shapes at this point—leave space around the parts.

> Then cut out all other pieces, using a craft knife and metal ruler to remove shapes from any piece marked with an X.

Get some card packaging that is thick enough so that no light can get through—the card from a cereal box is perfect—and glue the front light blocker to it, as well as the internal light blocker (with the black side showing).

Once the glue has dried, precisely cut out the three template shapes and remove the hexagonal hole from the internal light blocker.

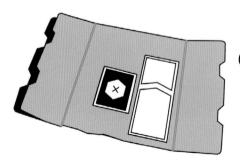

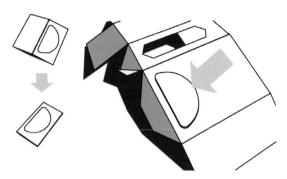

Fold over and glue the grab pad (7) to make it double thick, then cut it out and glue it to the marked spot on the sliding shell (6).

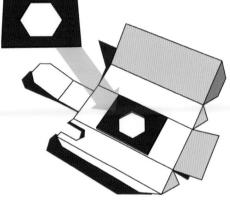

Glue the internal light blocker to the inside of the camera body (1), with the black side on the inside of the camera to minimize reflections inside the cameras. Make sure the hole in the blocker lines up with the hole in the front of the camera.

You can now assemble the camera body, following the fold lines marked on the template to form the box shape.

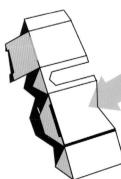

Glue the smaller front light blocker face to the front of the fixed shell piece (5). Make sure that the blocker is centered from top to bottom, and that the right (angled) side is flush with the right edge of the shell.

Glue and assemble the fixed shell, using the fold lines on the template as a guide.

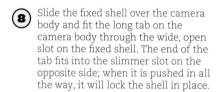

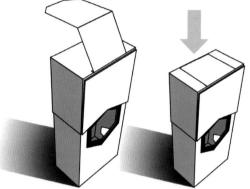

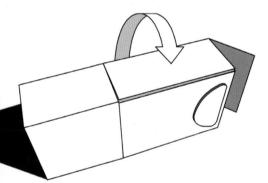

Next, score and fold the sliding shell, and wrap it tightly around the camera body to see how it fits.

> While you have it wrapped around the camera body, glue it together at the bottom. This way, the sliding shell will neither be too loose nor too tight.

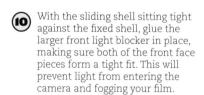

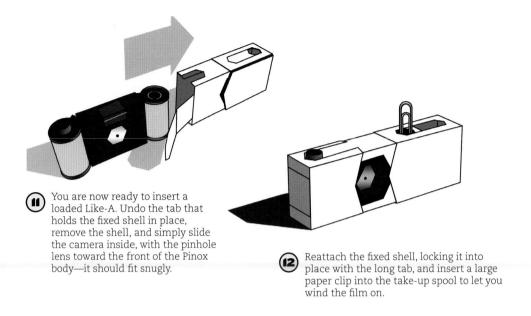

Using the Pinox

With your Pinox loaded, advance the film one-and-a-half turns to your first frame.

To make an exposure, simply slide the shell open to expose the film, count down your exposure time, and then slide the shell closed again. Wind on to your next frame by using the paper clip to turn the take-up spool three-quarters of a turn.

When you reach the end of the film, unlock and remove the fixed shell and take out your Like-A to rewind the film.

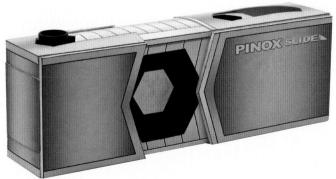

WHAT YOU NEED

- A loaded Like-A camera
- Four sheets of card (135lb / 220gsm)
- Craft knife
- Metal ruler
- Pinhole lens (see page 20)
- Black marker pen

Thrillium Fox Holebot

The Thrillium Fox Holebot is a steampunk creation that harks back to a bygone age when brass and wood were the materials of choice for the discerning pioneering photographer. It's also the perfect pinhole tool, with built-in legs and a viewfinder to help you frame your shots.

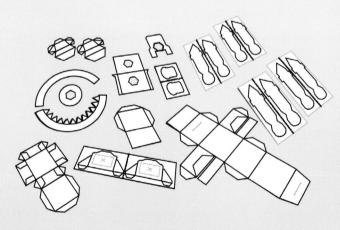

The Thrillium Fox Holebot template requires three sheets of card to print on, but you'll need a fourth sheet to strengthen the camera's legs.

Start by printing out the template and then glue the page containing the camera legs (11) and leg brackets (12) to your blank piece of card so it has double thickness.

Cut out all the pieces and use a craft knife to remove shapes from any piece marked with an "X"except the viewfinder (5).

Glue the camera body interior (1) tabs to the camera body (2), right behind the shaded areas that mark the position of the vents. The tab-less portion acts as a spacer and sits inside the rear block of the body to create an empty box in the back of the camera.

Assemble and stick the back of the camera body, and stick the tabs from the front to the sides of the camera body to finish it.

Glue the lens shade interior rim (8) to the back of the outer rim (6). The outer rim should be centered in the middle of the triangle tabs, so only half of it is stuck down.

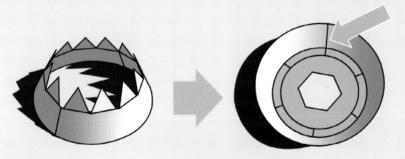

Carefully curve the rims and glue them together to complete the lens shade. Make sure the pieces are lined up properly and press them together firmly.

When the glue is dry, cut the tips off the triangular tabs, make the rim circular, and glue the lens shade ring (7) into the center of the rim. Snip the ends off any triangle tabs that show through the hexagonal hole in the middle.

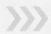

Assembling the Shutter

- Assemble the shutter by gluing the back section of the shutter casing (13) to the middle section. Apply the glue to the thin struts on the middle section, and clean any glue that seeps out to stop it hindering the shutter.
- Color the pull-tab (10) black on the reverse of the printed black area. Carefully apply glue to the middle section of the shutter casing, position the pull-tab into its sliding hollow and then glue the shutter closed. Apply firm pressure to make sure the glue dries evenly and test the pull-tab to make sure it works and to prevent any extra glue from seizing the mechanism.

Don't worry that the pull-tab can slide through the bottom of the shutter casing at the moment.

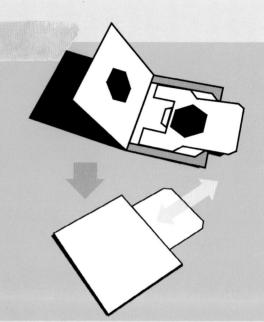

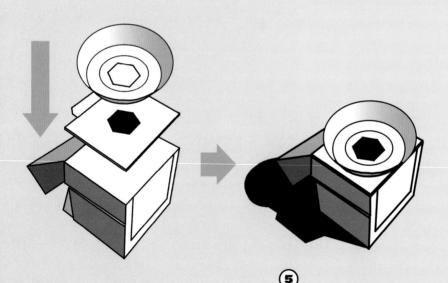

Glue the completed shutter mechanism to the front of the camera body, and then stick the lens shade to the front of the shutter mechanism, lining up the hexagonal holes.

The next stage is to assemble the legs. Fold each leg over and stick them together to create pieces that are four pages thick. Double-sided tape works well here.

If you glue the legs, wait until the glue is dry, then carefully cut the legs out. The card is four layers thick, so it will be difficult to cut—use several lighter cuts rather than trying to cut through all of it at once.

Score the leg brackets and glue them to the tops of each leg where marked. The brackets are designed to fit on one side of the leg, and should be a perfect fit.

Assemble the leg base (9), which folds into a simple box.

Glue each leg onto a corner of the leg base in the indicated areas. The large colored section of the leg base should be on the underside, between the legs.

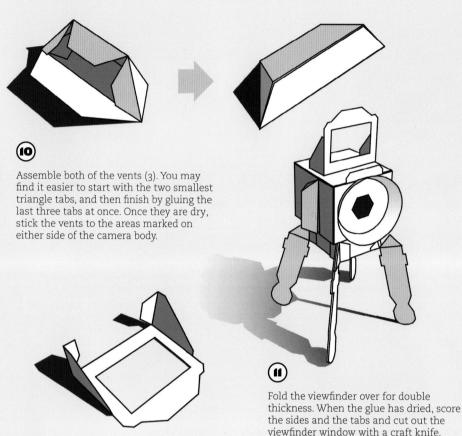

Glue the viewfinder to the top of the camera body, sticking the tabs in the white areas.

Stick the completed body to the top of the leg base, making sure that the shutter is aligned with the front of the camera to stop it sliding downward.

Fold over the locking tab (4) and glue it for double thickness. Carefully cut it out after the glue has dried.

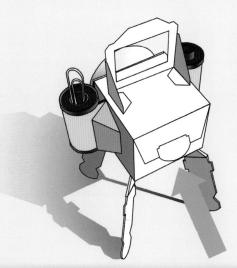

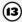

Finally, open the top of the Thrillium Fox Holebot, and slide your Like-A into the camera body. Tape the film rolls to the Like-A first to stop them falling out.

Close the top of the Thrillium Fox Holebot body and insert the locking tab through both of the slots in the back of the body to keep it shut.

Using the Thrillium Fox Holebot

You can wind on the film in your Thrillium Fox Holebot using the paper clip. To get your first frame in position advance the film one-and-ahalf turns.

Aim your camera using the viewfinder and consult the exposure chart to see how long you should expose your shot. Next, slide the shutter upward to open it and begin your exposure; slide it closed when the time is up.

Wind on your film using the paper clip in the takeup spool, turning it approximately three-quarters of a turn to advance to the next picture.

When you want to remove the Like-A, pull out the locking tab all the way, open up the back of the Thrillium Fox Holebot, and slide the Like-A out.

Chompy

Chompy is one of the cutest pinhole cameras you're ever likely to come across, and he makes a great gift, as well as a fantastic pinholing companion. His unique mouth shutter literally "eats up" the scene in front of him, and he even comes in a choice of two colors!

As with all of the paper camera projects, start by printing out your chosen Chompy template on 135lb (220gsm) card before cutting out, scoring, and folding all the pieces.

■ A loaded Like-A camera

 2 sheets of card (135lb / 220gsm)

- Craft knife
- Metal ruler
- Pinhole lens (see page 20)
- Glue
- Black marker pen

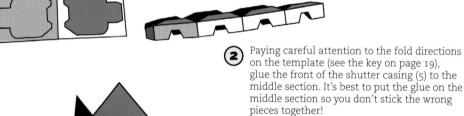

Color the back of the pull-tab (7) and pull-tab spacer (6) black to prevent light from entering the pinhole while the shutter is closed, then glue the pull-tab spacer onto the pull-tab.

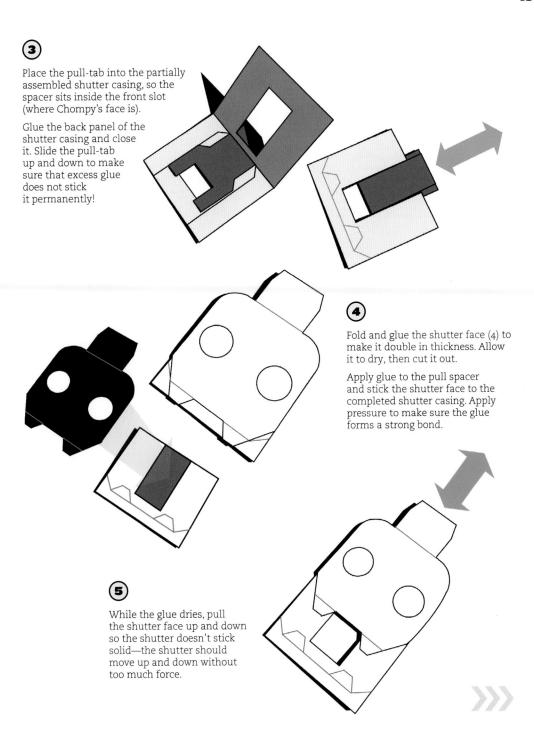

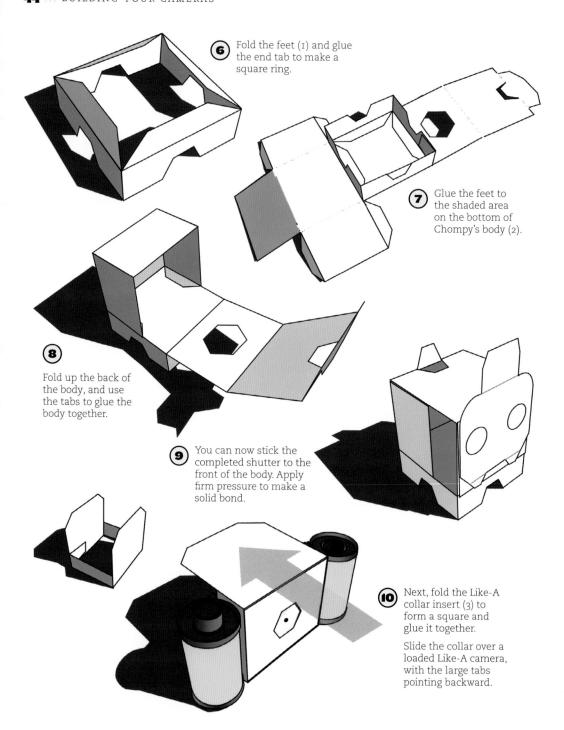

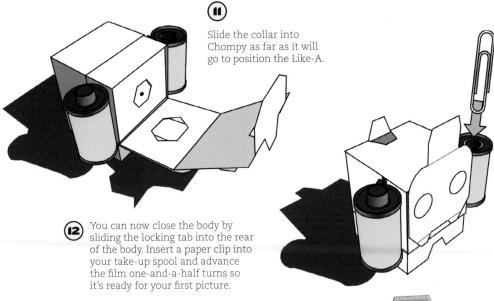

Using Chompy

To take a picture with Chompy, simply pull up on the shutter tab to open his mouth and expose your film. Close it again when the exposure is made and use the paper clip to advance the film three-quarters of a turn to ready your next exposure.

When your film's finished, remove the Like-A and rewind it as described on page 69.

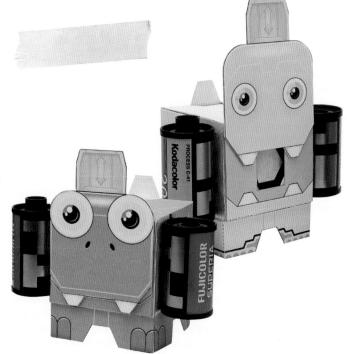

WHAT YOU NEED

- A loaded Like-A camera
- Three sheets of card (135lb / 220gsm)
- Craft knife
- Metal ruler
- Pinhole lens (see page 20)
- Glue
- Black marker pen

Stencil Cam

Stencil Cam is the wildest pinhole camera in this book—not only because of the way it looks, but also because of the pictures it takes. Cut-out stencils slide in front of the lens to produce pictures with irregular frames, and if there's not one on the template that you like, you can easily make your own.

Print out the template pages and cut out the camera parts. Keep the two stencil pages to one side—you can choose which ones to cut out and use later.

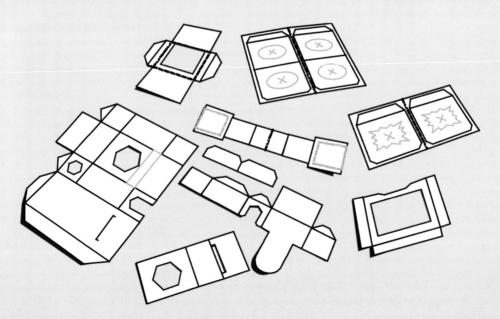

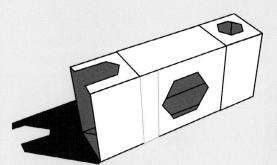

Use the lines on the template and the key on page 19 as a guide to assembling the camera body (1).

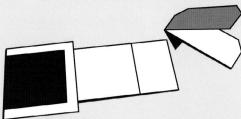

Fold over and glue the shutter pull-tab (2). Fold the shutter handle (3), but DO NOT glue it yet.

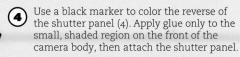

Position the shutter pull-tab behind the shutter panel so it sticks out of the end, then glue on the shutter handle.

Now glue the rest of the shutter panel to the front of the camera body to lock the shutter pull-tab in place.

5

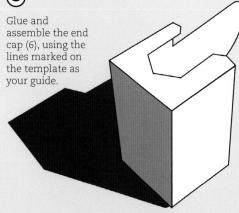

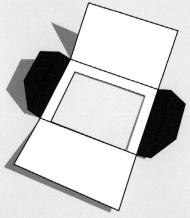

Use a black marker to color the reverse side of the stencil backer (7)—the whole of the inside of the stencil backer should be black so that light is not reflected onto the back of the stencil frame.

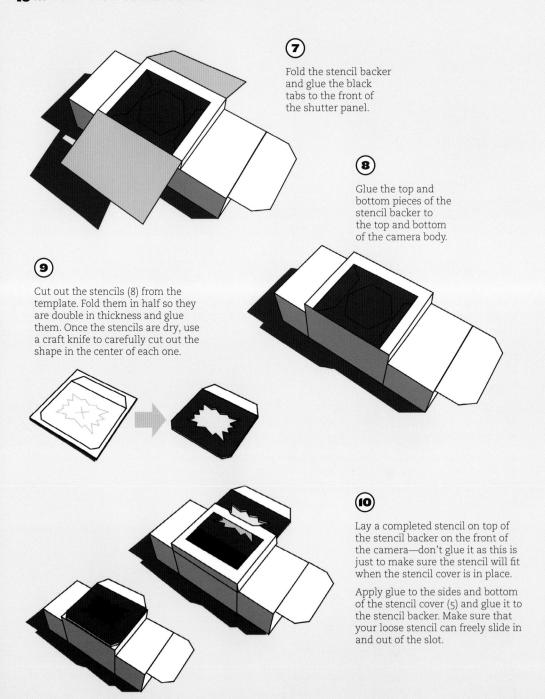

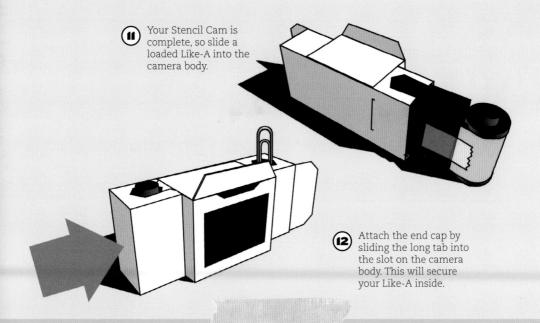

Using Stencil Cam

With your Stencil Cam loaded, insert a large paper clip into the take-up spool and advance the film one-and-a-half turns to get it ready for your first picture.

Choose which stencil you want to use and slide it into the front of the camera.

Decide on your exposure time using the exposure guide, then pull the shutter tab at the side to expose your film.

Slide the shutter tab back into the camera to end the exposure, then wind the take-up spool three-quarters of a turn counterclockwise to the next frame.

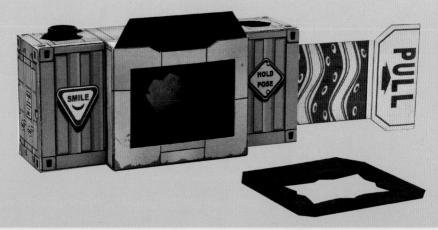

Camera Obscura

Finding a lens to focus on the rear wall of a room can be tricky and expensive. Below is a simple and cheap method for creating your own room-sized camera obscura.

A camera obscura (Latin for "darkened room") is the earliest optical device and goes back over 2500 years. Originally, projections were made through a small hole, but from around 1500AD onwards, camera obscuras began to use a lens.

The obscura below will project a "live" inverted image of the outside world into your home. By simply blacking out a room, positioning a lens, and hanging a projection sheet 90cm from the lens you will create a giant 2m × 2m inverted color projection of the outside world, 2500 years after

> Aristotle first wrote "WΩW, that's CΩΩL!" in his notebook!

You can create a unique space in your home for contemplation, teaching your kids (history, science, art, and optics), or merely to impress your friends! This is the definitive contrast to modern digital projections.

LEFT: Camera obscura shack at my local elementary school.

WHAT YOU NEED

- A +1dioptre lens. These are found in cheap reading glasses; look for the "1 dioptre" strength.
- A projection sheet. A cheap white semitransparent dustsheet or a plain white shower curtain works well as the image will be viewed through this.
- Material for blacking out a room. Black rubble sacks are a cheap solution, but for a reusable obscura I suggest spending some time cutting corrugated card to the size of the windows.

What Room is Best?

Any room with a window, which can be easily (and completely) blacked out, will be fine. If this can be on the ground floor all the better as you can "train" people to run around outside, hold up back-tofront lettering etc. Ideally, the window shouldn't point North (away from the sun).

Focusing and Hanging the Projection Sheet

After blacking out the window, cut out a hole the size of the lens and tape the lens to this hole.

The projection sheet needs to hang opposite the lens. Its distance will vary according to the distance of the subject, but infinity will focus at around 90cm. Test this by holding a sheet of white paper away from the lens until the image focuses on the paper. The sheet is then hung from the ceiling, and the image viewed "through" the sheet.

Condensation

In winter, condensation may appear between the lens and the window, which can be wiped off to keep a clear, sharp image. Double-glazed windows will be fine.

Pinhole Projection

This only works effectively in bright conditions, but if a sheet of tracing paper (ideally held within a frame mount) is moved towards and away from the hole, not only does the image stay in focus, but it also enlarges and reduces in size. You can also "skew" the image on an angled plane.

Room Obscura Setup

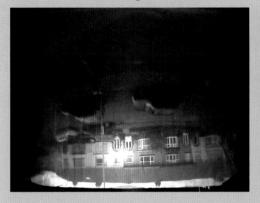

This is a room-obscura projection. The image was projected onto a sheet 90cm from the lens.

This example shows the size of the projection lens positioned within a blacked-out window.

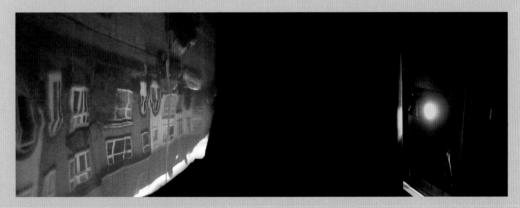

This wide-angle image shows both the projection lens in the window and the projected image on the sheet.

Plan view of the final constructed room obscura, including the seating arrangement.

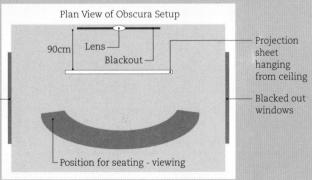

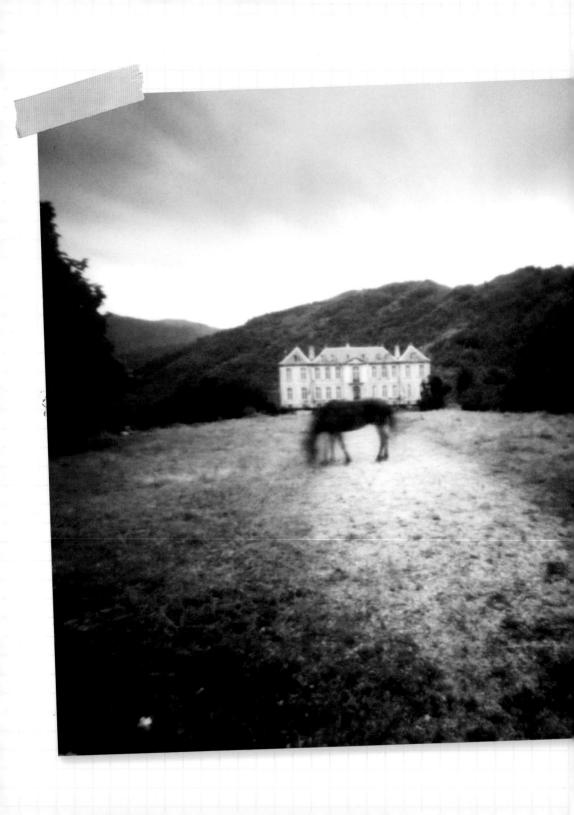

Making your paper cameras is great fun, but it's only the start of your adventure in pinhole photography—after all, what's the point of making a great camera if you aren't going to go out and take some equally great pictures?

However, unlike a regular camera (whether it's a compact or an SLR, or whether it's digital or shoots on film) a pinhole camera has its own unique qualities, which means things might not be as straightforward as you are used to—it certainly isn't a case of pressing a button and getting a perfectly exposed picture!

The main reason things aren't as "easy" with a paper camera is because of the tiny pinhole lens, but there's also nothing electronic in the camera. This means it's down to you to make a lot of the decisions, rather than relying on the camera to do it for you.

But while pinhole photography might not be a "point-and-shoot" exercise, that's exactly where the appeal lies—it's all about you taking control; not only when it comes to deciding what to take a picture of, but also how to make that happen, including what camera to make to do it! And with that tiny pinhole lens you made, your pictures will be guaranteed to have a unique look that sets them apart from everyone else's!

Over the following pages I'll walk you through the first steps of using your freshly built camera; from deciding which film to use and how to load it, to judging your exposures. There are also some great projects to help get you started.

Image © photographer Dianne Bos.

Color Photography

The paper cameras that you can make with this book use standard 35mm film. This type of film originated from early cine film stock, and prior to the arrival of digital photography it was the most common type of film used in compact cameras and SLRs. Having been the main film format for around 50 years, 35mm film is still widely available—despite the "digital revolution"—and there are plenty of places that will process it for you and provide you with prints, whether it's a camera store or your local drug store.

The quality of 35mm film is excellent, even compared with many digital cameras. Once you have got the film processed (or had some prints made) there's no reason why you can't scan them into your computer if you want to email your pictures to your friends, upload them onto the internet, or play around with them in your imageediting program. We'll come back to that in the next chapter.

RIGHT: Indoor lighting can add unusual colors to your pinhole pictures, like the eerie green flow of fluorescent lights.

FAR RIGHT: Shooting directly into the sun is rarely recommended, but the light shining directly through the tiny pinhole lens can create a colorful effect.

Types of Film

The most common type of 35mm film (and the one recommended for paper pinhole cameras) is color negative, which is designed for printing rather than viewing directly. As the name suggests, the pictures develop on the film in colors opposite to the ones in the scene, so green areas like trees and grass look a reddish color on the film. This doesn't really matter because the image is reversed and the original colors are restored when the negatives are printed onto a special type of photographic paper at the lab.

Color negative film isn't the only option, and 35mm film is also available in transparency (also known as "slide film") and tungsten-balanced options. The differences between these two typesand their suitability for paper pinhole cameras are explained on page 56.

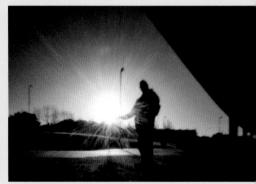

Film Speed

As well as different types of 35mm film, there are also different "speeds," which is basically how sensitive the film is to light. The speed of a film is given as an ISO or ASA rating (the two values are the same, and if you own a digital camera you may already have noticed it also has ISO settings). The higher the ISO number, the "faster" the film, or the more sensitive to light it is.

At the slow end of the scale are films up to 100 ISO. These are "fine-grained" films, which means they give the sharpest pictures with the most detail. Because they are "slow," the film needs to receive plenty of light, which means using longer exposures. As your paper camera uses a tiny pinhole lens, using slow film means exposure times can last minutes, or even hours, and anything moving will become a blur. If you want to avoid this, you might not want to use the slowest films, but if you want to create some dreamy, abstract pictures that convey motion, they're definitely worth experimenting with.

At the other end of the speed scale are "fast" films, which refer to any film over 800 ISO. Using a fast film in your paper camera will mean your exposure times are shorter, and if you want to freeze movement in a picture you'll stand a much better chance. However, the faster the film is, the more "grainy" it will be, and this will mean that some detail can disappear. More importantly, if your camera isn't completely light-tight, you may find that parts of the film are exposed while it's in the camera—even when the pinhole lens is covered. This is because it doesn't take much light to expose the film, so even the slightest "light leak" can affect the film.

ABOVE: Warm tungsten lighting gave an orange color cast as I strapped a camera to my shopping cart and took it for a ride around the store.

Between the slow and fast films are mediumspeed (200 or 400 ISO) films, and these are the best ones to use in your paper camera. The most common speed is 200 ISO, and you'll be able to get this from most stores that sell film.

With a 200 ISO film speed you can get greatquality photographs, with reasonable exposure times. As long as your camera's fairly wellmade and you don't leave it in direct sunlight, minor light leaks will also be less of a problem, so you'll get more successful pictures!

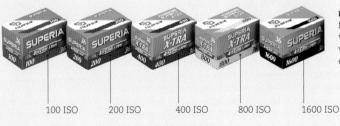

LEFT: Negative film comes in a variety of speeds, which affects the exposure time.

Getting Your Film Processed

Processing laboratories usually do a pretty good job of printing pinhole negatives, but it's always worth telling the person behind the counter that you used a pinhole camera, and ask them not to cut your negatives into smaller strips. This is because pinhole photography with a paper camera isn't an exact science, and sometimes you'll have frames that overlap slightly, or are even on top of each other. But this isn't always a bad thingsometimes two partly overlapping frames can make one great picture, so it would be a real shame if the person at the lab cut them in half!

As well as your negatives, you're also likely to get prints made at the same time (some places don't give you a choice). This is great, but it only gives you one print of each picture. If you've got a computer and printer at home, and the lab offers a "develop only" service, think about asking them to scan your film for you rather than printing it. That way you'll have a digital file for each image which you can edit and print as many times as you like when you get home.

If you've got a scanner that can scan film, then why not just get the film developed and do the scanning yourself, as well as the printing? That way you'll have almost complete control over your pictures and the way they look.

BELOW: Slide film is not really suitable for paper cameras.

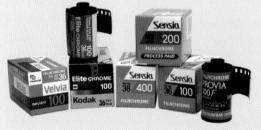

Alternative Film Types

Transparency: Also known as slide film. transparency film gives "positive" images, so when the film is processed the colors look right on the film. This makes it easier to scan than negative film, but unlike negative film it needs to be exposed very precisely. If you overor underexpose the image (even by a small amount), the pictures can easily be ruined. For that reason, most pinhole photographers avoid shooting on slide film, and it's not really recommended for using in your paper cameras.

Tungsten film: Available as both negative and transparency film, tungsten film is designed to be used indoors with regular domestic light bulbs to avoid the orange color these lights normally produce in a picture. But this doesn't mean you can only use it indoors—if you use tungsten film outdoors in daylight, it will give your pictures a cool blue look, and this can look great with paper camera pictures. The only disadvantage is that tungsten-balanced film is hard to track down—especially color negative tungsten film—so you'd need to drop in to your local camera store to see what's available.

LEFT: Tungsten film is designed for taking pictures indoors under tungsten lighting.

OPPOSITE: This looming swan was taken on 35mm film with the camera placed on its back on the ground. I ensured the camera was in the shade for the length of the exposure.

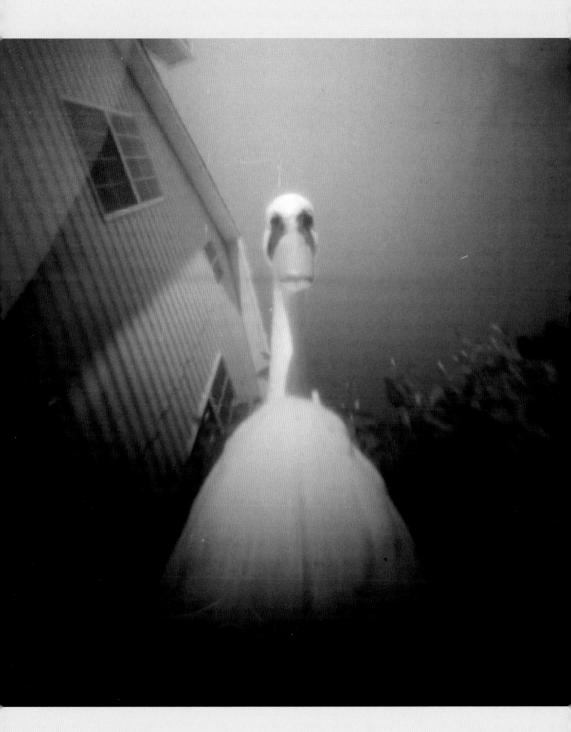

Black-and-white Photography

As well as taking color photographs, a lot of photographers like to shoot their pinhole pictures using black-and-white negative film. This type of film works really well in pinhole cameras as it has a wide "exposure latitude," so even if your pictures are over- or underexposed it doesn't matter too much—the film will still record the detail

Although black-and-white film isn't as easy to get hold of as color film (it might mean a trip to a camera store, or ordering online) there is still a wide range available, from ultra-slow 25 ISO films, right up to 3200 ISO film, although a mediumspeed 400 ISO film is best if you're starting out.

Like color film, all of these different speeds can be used in your paper camera, with slow films giving very detailed pictures (but long exposure times) and fast films that are incredibly sensitive to light giving incredibly grainy, textured results that are full of atmosphere. If you're processing the film yourself, you can even "up rate" a fast film to make the grain even more of a feature (see box).

Processing Black-and-white Film

While it's easy to take color film to a lab or drugstore and get it processed and printed (or scanned), you might find your local drug store doesn't process black-and-white film, or they'll send it away for processing and you'll have to wait a few days for it to come back. It can also cost a bit more to get the film processed and printed, but don't let this put you off shooting in black and white.

One of the great things about black-andwhite film is it's really easy to process at home if you've got the right equipment; so once you've taken your pictures, there's no reason why you can't do the developing yourself and really get involved in "making" your pictures.

Film-processing tanks and the other bits and pieces you need can be picked up for very little money on internet auction sites. You can

> also find instructions on how to develop film online, so even if you've never done it before you can give it a try.

LEFT: Black-and-white film is still being made, and there is a wide range of speeds available.

Chromogenic Film

"Chromogenic" films—such as Fujifilm Neopan 400 CN, Ilford XP2 Super, and Kodak BW400CN—are a special type of black-and-white film that's designed to be processed in the same chemicals as color negative film, even though it gives black-and-white prints. This makes them a great option for your paper cameras if you want to combine the beauty of shooting in black and white with the ease of processing of color negative film.

Uprating Film

Uprating film is a clever way of "pretending" your black-and-white film is faster than the manufacturer says it is, so you get a shorter exposure time. There's nothing you change on the film itself (it's not like changing the ISO on a digital camera), you just expose the film for less time. Normally, this would mean your pictures come out too dark, so to prevent this, the film is developed for longer (known as "push processing").

Photographers use push processing because it not only reduces exposure times, it also increases the grain and the contrast in the pictures, which is an effect a lot of people like.

However, pushing your film is something that's only really worth considering if you are going to develop your film yourself, as not all labs will be happy to push process your film and you might have to pay extra for the service. If it's just bigger grain that you're after, you might as well just use a faster film to start with.

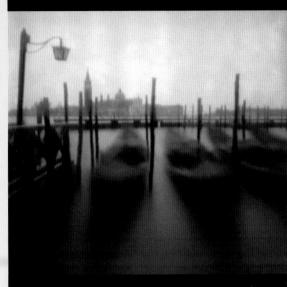

ABOVE: This black-and-white photograph of Venice looks far older than it is, and this vintage feel is part of the appeal of shooting in monochrome.

ABOVE: Using fast film—or uprating your film—will give shorter exposures to help catch fleeting moments.

Black-and-white Infrared

As well as "normal" black-and-white film, some pinhole photographers experiment with the weird characteristics of infrared (IR) film, to produce some truly unique pictures.

The reason the pictures look so strange is because IR film doesn't see light in the same way as our eyes. Instead, it's sensitive to "invisible" infrared light. With IR film, a blue sky will normally turn black, while vegetation like trees and grass appear to be glowing white!

To get these ghostly results, you need to use a special filter with your camera, and this can be fitted in front of the pinhole lens, or behind it. More importantly, though, the film needs to be handled in total darkness, otherwise it can be ruined by infrared light. But, if you're happy to load and unload your camera in the pitch black you can get some stunning pictures—especially with a pinhole camera.

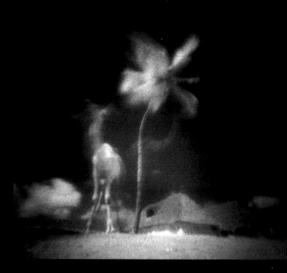

ABOVE: Infrared film is a special type of film that records "invisible" infrared light to give spooky results.

Digital Black and White

If you plan on scanning your pictures into your computer, you might want to think twice about using black-and-white film in your camera.

There's no reason why you can't, but if you shoot in color and then convert the pictures to black and white in your image-editing software, you have the choice of the original color photograph and a digital black-and-white version.

You can also try experimenting with film grain filters in your software to add the sort of texture you might get from a fast black-and-white film.

RIGHT: For this band picture, I shot in black and white so there wasn't any distracting color.

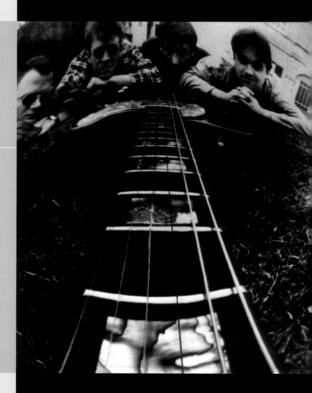

ABOVE: Because pinhole cameras cost very little to make, you can experiment with different techniques—like underwater photography, for example. Wrap your camera in a clear plastic bag and see what happens.

Loading Your Camera

Once you've made your camera and your lens is in place, it's time to load it with film and get out and start shooting. It doesn't matter whether you've made the basic Like-A camera or one of the more advanced models, as the film-loading steps are the same for each—starting with you making a "take-up" spool.

Take-Up Spool

The take-up spool is where your exposed pinhole pictures will be kept when they've been shot. To make a take-up spool you'll need a spare roll of film that you don't mind wasting. The reason it's going to be "wasted" is because the first step is to pull all of the film out of the cassette, which will expose it to light.

Cut the film off about 4 inches (10cm) from the end, so you're left with a short "tail" hanging out of the cassette.

Next, carefully cut off the top turning knob. This is tough, so BE CAREFUL! Removing the knob means your camera will sit flat when you're taking pictures or, with some of the more advanced designs, means your Like-A will fit into the camera shell.

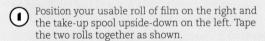

The light side of the film (the emulsion side) must face towards the pinhole lens.

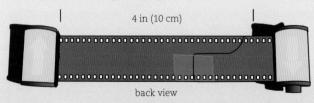

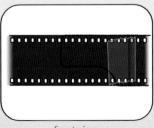

front view

Position the film inside the back flap of the Like-A camera, so the unexposed film is on the right (looking from the back of the camera) and the take-up spool is on the left.

Close the back of the camera over the film. Slide the side tabs into the film roll on the right. Avoid pulling too much film out and exposing it!

Slide the take-up spool onto the tabs on the left side of the camera. Let the film push into the canister as you slide it onto the tabs.

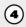

If you are using the basic Like-A camera, without one of the optional camera shells, you will need to tape the "camera cape" to the top and bottom of the camera to ensure it's as light-tight as possible. Tape both of the film cassettes to the cape to keep them from falling off and ruining your film.

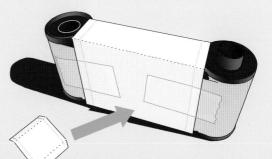

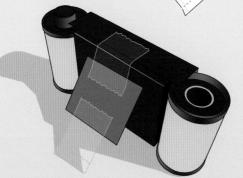

If you're using the basic Like-A camera, you can make a simple shutter using a piece of thick card and some tape. It's a good idea to color the shutter black on both sides with a thick black marker pen, or Sharpie, as this will stop light passing through the card. Your camera is now loaded and ready to use!

Exposure

It doesn't matter if you take photographs with a film camera. a digital camera, or even a pinhole camera—the basic way that a picture is formed (the "exposure") is the same. It comes down to a combination of three things: the amount of light coming through the lens; the amount of time the film or sensor receives this light; and the sensitivity of the film or sensor to light. It's all about the aperture, the shutter speed, and the ISO.

BELOW: A six-month duration exposure of the Clifton Suspension Bridge in Bristol. The light trails show the sun tracking across the sky from winter to summer. Taken with a beer-can camera on photographic paper.

By controlling these three things, a photographer can produce a "correct" exposure that isn't too dark (underexposed), and isn't too light (overexposed). With modern digital (and film) cameras the process can be alarmingly simple just switch the camera to "automatic," press the shutter button, and let the camera do the complicated bit for you!

With pinhole photography this isn't an option. Your paper camera doesn't have sophisticated electronic processors built into it to measure the light coming through the lens; it doesn't have variable apertures; and the shutter speed depends entirely on how long you keep the lens open. But the fact that a pinhole camera is so "dumb" is what makes it so refreshing-it's all about the craft of photography, not the technology.

Understandably, this means that in the world of pinhole photography there is almost as much anxiety about exposure times as there is about the pinhole size, but the easiest way of judging the exposure is by not worrying about it!

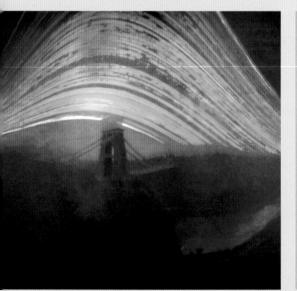

200 ISO Exposure Times

Use the following times for exposures using 200 ISO speed negative film.

Bright Sunlight 2 seconds Hazy Sunlight 4 seconds Thin Cloud to seconds Thick Cloud 30 seconds Indoors (brightly lit room) 5 minutes Indoors (dark room) I hour Night All night!

Hassle-free Pinhole Exposures

Working out how long you need to expose the film when you're using a pinhole camera isn't easy, but it isn't an exact science either, and there are plenty of things that will help. For a start, the aperture on your camera will never change because your lens is nothing more than a tiny hole in a piece of metal. Providing it's around 0.2mm in diameter, that's one part of the equation you don't have to worry about.

Second, if you want to keep things simple, load your camera with 200 ISO negative film. As we saw earlier, the exposure latitude of negative film (color or black and white) is really wide, which means that even if your exposures are some way off "correct" the film will still record a picture that can be printed.

So with the aperture and sensitivity "fixed," that leaves only one exposure control that is variable—the shutter speed. How long do you expose your film to get the correct exposure?

The answer is: you guess.

It might sound like a slightly trite answer, but only one thing affects the time you need to keep the shutter open: the brightness of the scene in front of you. This comes down to the brightness of the light source illuminating the scene, and the amount of light being reflected off it.

To keep things very simple, the accompanying table on the left tells you how long you should allow for your exposure. It's only a guide, but assuming your aperture's roughly the right size and you're using 200 ISO film, it's all you need to get started with your paper camera. It's that simple!

RIGHT: A good exposure will have good detail in both the shadow and highlight areas.

When Exposures Go Bad

If your exposures are too long, then your pictures will be too light. Here, the overexposure results in a cyan sky and dark red "blacks," as well as an overall reduction in contrast

Underexposed pictures will appear dark, as the film hasn't received enough light. The detail in dark areas will disappear completely, and it's impossible to recover it.

The correct exposure will have a full range of tones from dark to light. This will mean your colors stay true to the original scene.

Overexposed

Underexposed

Good exposure

Advanced Exposure

Although it's fairly easy to decide how long you need to keep the shutter open on your paper camera, things get a little harder if you want to start using different film speeds. If that's the case, then other variables start coming into play, and following the "2 seconds if it's sunny" rule no longer works. Or rather, it does still apply, but you need to do a bit of math to apply it to your new film speed.

Slower Film Speed

Although 200 ISO film is recommended for your paper cameras, there's no reason why you can't use slower film—you just need to make your exposure times longer. Luckily there's a really easy way to work out how much longer you need to make your exposures because every time the ISO is halved, the exposure time is doubled.

So, if you want to use 100 ISO film instead of 200 ISO, for example, you can just double all the times

on the previous page; instead of exposing for 2 seconds under bright sunlight, you'd need a 4 second exposure, and a 10 second exposure on a cloudy day would become 20 seconds.

If you go slower still—to 50 ISO—then you'd double the exposure twice, so you'd end up with 8 second exposures in bright sunlight, and 40 seconds under cloud. However, you'd also have to add a bit longer to counter reciprocity failure, which is where things start getting complicated...

Reciprocity Failure

The rule that halving the ISO doubles the exposure time is simple to follow, but beyond 10 seconds things change, and the reason for this is something called "reciprocity failure." As exposures get very long, the film effectively becomes less sensitive to light. The answer is to make the exposure even longer, but this isn't an exact science—the longer the exposure gets, the more time you have to add. If you want to be really scientific about it you can visit the film manufacturer's website, or simply use the table on the page opposite as a guide!

RIGHT: This extreme-pinhole picture was taken by exposing photographic paper (not film) for several months—the light trails in the sky are actually the sun.

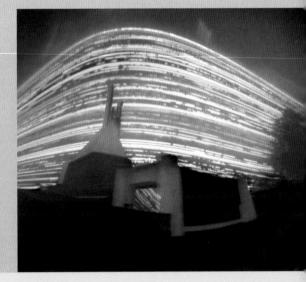

aster Film Speeds

You can also use faster film to reduce your exposure times or add grain to your pictures. In this case the way of working out your exposures is eversed compared to slow film—doubling the ISO will halve the exposure time.

So, if you use 400 ISO film, you can slash all the exposure times on the previous page in half (so you'd expose for I second in bright sunlight, 5 seconds on a cloudy day, and so on). Increase the speed to 800 ISO and you can half them again (1/2 second bright sun, and so on).

BOVE: Outside, with fast film and good light, exposure times can be so short that even a speeding chicken will come out sharp!

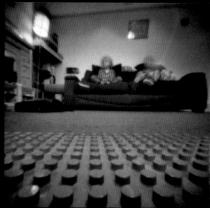

ABOVE: Indoor exposures can last for hours,

Exposure Times For Different Film Speeds

The following table gives the rough exposure times for different film speeds, taking into account reciprocity failure. These figures are by no means guaranteed to work with every single film, so experiment—it's all part of the fun of

pinhole! And remember, when you start exposing for minutes at a time, a few extra seconds are unlikely to make much difference, and adding more light is better than adding too little.

Film Speed (ISO)	50	100	200	400	800	1600
Bright Sunlight	10 seconds	4 seconds	2 seconds	1 seconds	•	* 28.55
Hazy Sunlight	30 seconds	10 seconds	4 seconds	2 seconds	1 seconds	*
Thin Cloud	90 seconds	30 seconds	10 seconds	4 seconds	2 seconds	1 seconds
Thick Cloud	5 minutes	90 seconds	30 seconds	10 seconds	4 seconds	2 seconds
Indoors brightly lit room	1 hour	20 minutes	5 minutes	90 seconds	30 seconds	10 seconds
Indoors dark room	10 hours	3 hours	1 hour	20 minutes	5 minutes	90 seconds
Night	All night!					

Your First Photos

Using a pinhole camera is very different from using a regular camera, because you don't have any of the electronic systems you are probably used to. Not only that, but there isn't even a viewfinder or a shutter button! However, taking pictures is still really straightforward, and it's actually helped by the fact that there isn't anything to distract you from the actual picture-taking experience.

Open the Shutter

If you stuck with the basic Like-A camera model you'll need to release the tape you've used to hold your shutter closed. The other cameras have a more sophisticated shutter mechanism that you can flip or slide to reveal your pinhole lens.

Rewinding Your Film

Although your paper camera doesn't have a frame counter telling you how many shots you've taken, you can tell when you are at the end of the film because you won't be able to wind it on any more. When this happens you need to swap your paper clip from the take-up spool to the original film cassette and "rewind" the film back into the cassette by turning the paper clip counterclockwise. With some of the camera designs, you may find this is easier to do if you remove the Like-A first.

You should rewind your film in subdued light, not direct sunlight, and keep turning the paper clip until you can't turn it any more that tells you you've rewound your film fully.

When your film is rewound you can remove the exposed film and the take-up spool from the camera, and unfasten the tape that holds the two together. Your take-up spool is now ready to be used again, and your exposed film is ready to be taken to a lab and processed.

Make Your Exposure

Keep the shutter open for the time indicated by the exposure chart. With really long exposures (ten seconds or more) you don't need to be too precise, as a second more or less will make little difference. With shorter exposures, try and stick to the exposure time to avoid your pictures coming out too light or too dark.

At the end of the exposure, close the shutter.

Wind the Film On

Using a large paper clip in the hole at the top of your take-up spool, wind the film on to the next frame by turning the paper clip three-quarters to one full turn clockwise.

You're now ready to go back to step one and take another shot!

Landscape **Photography**

Landscape photography began in the 19th century, just as the world was opening up to travel and exploration. At the same time, advances in photography—with the invention of the dry plate and eventually roll film-meant that photographers didn't have to coat plates with light-sensitive emulsions just before they used them. The plates didn't have to be processed immediately after they had been exposed either, making the whole photographic experience far more portable. Since then, lensbased photography and capturing the landscape developed hand in hand.

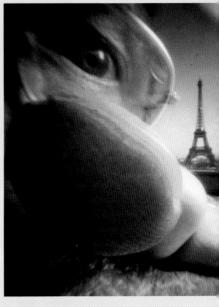

ABOVE: This Paris cityscape was taken with my finger almost touching the pinhole. Fill-in flash was used for extra illumination.

When photographing landscapes with a pinhole camera, we need to look beyond conventional image making. Although it is fairly easy to imitate lens-based photography, your pinhole camera has a much greater potential to create a unique vision of the landscape.

For a start, the paper pinhole cameras in this book have a very wide angle of view. The cameras you'll be building "see" around 75 degrees horizontally in front of the camera, whereas, if we keep our eyes still, a human's clear vision is around 40 degrees.

So why is this special? When you use short focal lengths like these you not only get more of the scene in front of you into the picture, but the distance between objects close to the camera and those farther away appears to be increased, although obviously they don't actually move away from each other! With

your wide-angle pinhole camera, this means you can really emphasize the space between objects in the foreground and those in the distance.

You can add even more drama to your landscape pictures if you shoot from a low level. Most photographs we see are taken around 5-6ft (1.5-1.8m) from the ground (simply because this is "eye-level" for the majority of people), so we are used to seeing the world from this viewpoint. However, any radical change to this height immediately creates a more intriguing image, so try shooting landscapes from ground level for a "worm's eye" view of the world, or place the camera on its back, with its lens looking upwards-the pictures might not amount to much, but you don't know until you try!

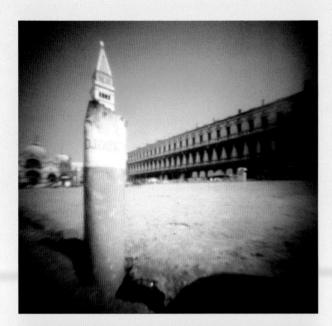

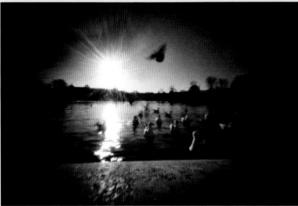

TOP: Your paper camera's wide-angle lens and huge depth of field makes it perfect for playing around with alternative viewpoints.

воттом: Wide-angle pinhole lenses exaggerate perspective. Combined with a low viewpoint they can really draw you into the picture.

Movement and Blur

Something that pinhole cameras are naturally very good at doing is recording movement because they require long exposure timeseven a couple of seconds is long enough to flatten the waves on the sea, or record a breeze in a tree's branches. Many landscape photographers have perceived and captured energy in the landscape, and your camera will be able to capture all of these really easily, from the movement of waves. rivers, branches, and even clouds. to man-made moving objects such as automobiles, boats, and trains.

To make sure that only the moving elements are blurred, your camera must be held steady for the duration of the exposure by resting your camera on a wall, or maybe even taping it to the railings on a fence to record all the movement in your street. Why not go out at night and start recording the trails of automobile lights in the urban landscape, possibly contrasting them with solid, still office buildings or apartment blocks?

But, while it's necessary to keep the camera steady if you want parts of the picture to be sharply focused, don't be afraid to take the camera off the tripod, or attach it to some sort of moving platform such as a bicycle, car. or elevator. Sure, nothing will be sharp in the final picture, but it doesn't have to be-pinhole is all about experimenting with time, and a moving camera will blend colors together and create abstract shapes and patterns. These approaches are difficult to capture with modern automatic compact cameras, but pinhole cameras do it automatically!

Portrait Photography

When photography was invented, portraits required exposures of several minutes, which was far from ideal. To get a picture of someone that looked even half way sharp meant the sitter had to be physically clamped into position using a device that didn't look too dissimilar to a dentist's chair. The result—toward the end of the 19th century—was some fairly dour and uncomfortable-looking people, who seemed to possess madly staring eyes as they tried hard not to blink too often

If it were not for the necessity of keeping friends, the exposure times required for pinhole could easily bring back those glorious days, making portraiture one of the least appropriate areas for the pinhole photographer. However, it also has its advantages. We all have an idea of how we want to appear in photographs and we pose accordingly. To try and maintain this over a period of time tends

to remove the façade of the pose, resulting in a more honest representation. And, actually, keeping still during an exposure of several seconds is fairly easy if the sitter has their head in their hands or rests their head against a wall. Try experimenting with faster film to keep exposure times to a minimum—the grainy results can often be quite attractive—but if there is any movement, it often adds to the effect of a fleeting moment of time.

Pinhole photography can also produce some quite revealing candid photographs. For decades, the movement of lifting a camera up to your eye to peer through the viewfinder was instantly recognizable to anyone nearby that someone was about to take a picture, resulting in selfconscious portraits. Recently, this has been replaced by holding a camera (or cellphone) at arm's length to view a digital screen, which is slightly less conspicuous, but still not entirely discreet. A pinhole camera can be placed quite unobtrusively, and the fact that it needs to be left for several seconds means it doesn't give the impression that a photograph is being taken. As long as the subject doesn't move too much, you should be able to take some great shots of a person seemingly frozen in a world of motion.

Use Flash

Flash is covered in more detail on pages 76-77, but it seems appropriate to mention it here as it can dramatically reduce the time your subject needs to stay still. Using a regular flash unit with a manual test button, hold the flash away from the camera, pointing toward the subject. Start to make the exposure and fire the flash. The brief burst of light will "freeze" the sitter, while the full exposure will expose the background properly.

LEFT: Take advantage of the pinhole lens's closefocusing ability for radical wide-angle shots.

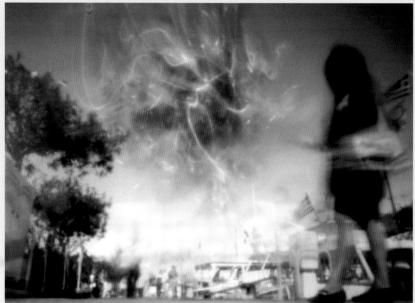

LEFT: A long exposure has turned this balloon seller's balloons into a kaleidoscope of color as they move in the breeze.

BELOW: Image © photographer Chris Gatcum. This long exposure and stark location gives an unsettling, supernatural view of man and beast.

Photographing Ghosts

A homemade paper pinhole camera won't actually allow you to take photographs of ghosts, but the long exposure times are perfect for creating portraits where the subject becomes a ghostlike form.

This is a technique that's really easy to try for yourself, and the best starting point is to use slow film to keep the exposure time quite long. Set up the camera in front of your subject, and open the shutter to start taking the picture. Part way through the exposure, get your subject to leave the scene. If they move reasonably quickly, their movement out of the frame is unlikely to be picked up, while the background they were previously concealing will continue to be exposed.

The result should be similar to the image shown here, and there are endless variations on this theme. For example, instead of moving out of the frame entirely, your subject could move to the other side of the picture, creating the appearance of ghostly identical twins.

Still-life & Close-up **Photography**

Still life is one of the oldest areas of photography, dating right back to the pioneers of the medium. Working with very slow emulsions (the equivalent of today's film speeds) these early photographers were faced with exposures that lasted minutes, and if anything moved during that time (or the subject wandered off) the result would be blurred. However, if the subject was inanimate—a leaf or a garden fork, for example—the photographer could make exposures for as long as they liked and the pictures would be sharp.

BELOW AND BELOW LEFT: The two pictures below show the fun you can have with your paper cameras. Still-life photography isn't just about taking pictures of bowls of fruit—sheep in a popcorn field, and monsters in your breakfast cereal are much more interesting!

It's pretty easy to see the parallel between those pioneers and the modern pinholer with his or her extended exposure times, so it's only natural that still-lifes make great subjects for pinhole photographers. But it's not only the fact that the subject doesn't move that makes still-life photography exciting with a pinhole camera—it's the way pinhole lenses work as well, especially when it comes to close-up photography.

For a generation of amateur photographers, the world within 40 inches (1m) of the lens was "out of bounds," simply because lenses couldn't be made to focus any closer than that without the addition of extension tubes and supplementary lenses. There also was (and still is) the problem of getting things very close to the camera in focus at the same time as keeping the background sharp.

Referred to as "depth of field," the closest and furthest points that are sharp in a photograph rely on a combination of the lens's aperture and the subject's distance from the camera. The closer a subject is to the camera, or the wider the aperture, then the narrower the depth of field, and the less of a scene appears sharp. Even today, that means there's no chance of focusing on a subject that's very close and a background that's some distance away—one or the other will be blurred. The pinhole photographer has no such restrictions, because the lens's ultra-small aperture gives an almost unlimited depth of field. So a point only inches in front of the lens can be in focus at the same time as a background that is many miles away.

BELOW: Pinhole cameras let vou get very close to a still-life subject, and still keep it in focus.

BELOW RIGHT: "Coming down the stairs"—all you need is a doll's house, your toes, and a paper camera!

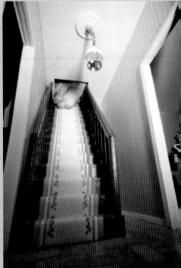

Using Flash

Very few pinhole cameras can be used with electronic flash due to the relatively large pinhole-to-film distance the traditional designs usually have, so flash isn't normally associated with pinhole photography. However, the paper camera designs that accompany this book have the pinhole very close to the film and so can be used with most flash units. making flash a useful tool to add to your armory.

RIGHT: Double bunny ears! Note the detail the flash gives to the rabbit's whiskers

The best type of flash for this purpose will be the sort that you might already have lying around for an SLR, which slots into the camera's hotshoe. If you don't have one already, then don't worry as we're not talking about a top-of-the-range flash unit that's dedicated to a particular camera system. All it needs to have is the ability to be triggered without being attached to a camera. and there are hundreds of flashes like this that are now available on the second-hand market at really low prices. If you want to buy one for your pinhole photography, look for one with a guide number between 24 and 32, which is a measure of the flash power.

In normal lens-based photography, you can use a flash like this to illuminate subjects up to a distance of around 15 feet (4.5m) away, but with the small aperture of a pinhole you will only be able to use the flash up to a distance of 12 inches (30cm). This may seem inhibitive, but when you combine it with the pinhole camera's ability to focus almost on the lens itself, and the very short duration of a flash that enables the camera to be handheld without the risk of camera shake, a new vision awaits.

Flash Fall-off

The light produced by a flash falls off quickly, so you need to be careful when positioning your subject. Here, the airplane is too close to the camera/flash and has been overexposed, while the figure behind is too far away and is underexposed.

Shooting With Flash

Using a flash with your paper pinhole camera involves photographing objects close up to the camera, rather than the usual "at a distance" convention, and you need to make sure the flash is set to its maximum power output. You can do this by switching the flash to its manual power setting, or, if there is no manual option, you can use a small piece of black tape to cover the sensor on the front of the flash.

The way you angle the flash is critical, as you will need to illuminate the subject without pointing the flash into the pinhole lens. Try holding the flash just above the camera, or to one side, making sure it points toward the subject.

Ideally, the flash-to-subject distance and the camera-to-subject distance should both be within 12 inches (30cm) for the best results, but negative film (color or black and white) has such a wide exposure latitude that even images that are overor underexposed quite heavily can be saved.

To take your flash picture, open the shutter on the camera, fire the flash, then close the shutterthe flash will effectively be making the exposure in a single "pop," so the actual time you need to keep the shutter open is fairly irrelevant. The only time it is important is if you want to expose the background as well, when it's best to expose the picture for the "correct" amount of time.

The Advantages of Using Flash

Indoor Photography: Using flash is a great way of taking photographs indoors with your pinhole camera. Objects around the house, or contrived scenarios, can be easily photographed in this way, making full use of the pinhole camera's unique "bug's eve" view for close-up images.

Avoiding Camera Shake: The short flash duration allows you to hold the camera, removing the need to rest it on a solid surface.

Capturing Movement: As well as preventing camera shake, a flash will also freeze movement in a picture, such as water splashes, insects and bugs, or people if you're taking portraits.

Increased Contrast: The flash will increase the contrast in a picture, which helps make the image look sharper.

Black Backgrounds: As the light from the flash won't travel very far (or at least the camera won't expose for it) the background of your picture will become black, isolating and enhancing the subject.

BELOW LEFT: Paper pinhole cameras can be put inside things, looking out—like a bag of candy, or the pocket of a pool table. The flash adds to the mystery.

BELOW: "Flash and blur" is a great technique. The flash freezes the subject and makes it sharp, but the long exposure adds blur.

Starter Projects

There are thousands—if not millions—of things to take pictures of, and the previous areas of landscape, portrait, still-life, and close-up are just the beginning. Pinhole cameras don't see the world the same way you do, so take full advantage of their extremely wide viewing angle and huge depth of field to exaggerate or distort the distance and scale of objects, or use the ultra-slow shutter speeds to record the movement of everyday life. The following projects will give you a few ideas to help you start taking your pinhole photography beyond the conventional

Project 1: The Automobile Windshield Squirter

This is a simple project to get you started, which makes use of a fixed subject that's very close to the camera (in this case, the windshield squirter on an automobile). At night, try combining this project with the Night-Time Light Trails project on page 80.

To recreate this shot, first find a car that's pointing away from the sun to prevent sunlight going directly into the pinhole. Place the camera on the hood, about an inch (2.5cm) from the squirter nozzle and open the shutter. After counting to the appropriate exposure time, close the shutter to stop the exposure.

RIGHT: Close-up image of a windscreen squirter "bug."

Project 2: Self Portraits

Stuck for something to take a picture of? Then why not turn the camera on yourself like some of the earliest photographers? There are traditionally two easy ways of doing this—either by photographing yourself in a mirror (or other reflective surface), or by holding the camera at arm's length and pointing it back at you. Because of your pinhole camera's incredible depth of field, almost anything in front of the lens will be sharp, so you can get in really close for some "extreme" portraits.

RIGHT. For this shot a mirror was used, but definitely not in the normal fashion! I took a mirror, and stuck my camera to one end of it, so it was looking along the mirror. I then placed the mirror on a flat surface and "bit" the end opposite the camera (be careful!) before taking the shot. Changing the position of your face will result in a variety of different looks.

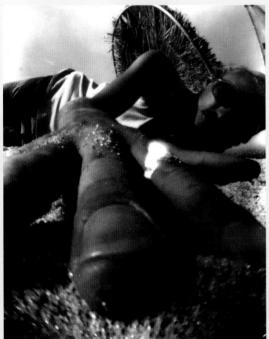

LEFT: My hand was almost touching the camera when I made this exposure (handy for opening and closing the shutter). The extreme perspective comes from the camera's exceptionally wide viewing angle, while the pinhole lens's massive depth of field keeps everything in focus.

ABOVE: Moving your head halfway through the exposure will give you instant double portraits.

Project 3: Night-Time Light Trails

This project makes use of a long, night-time exposure, and involves securing the camera onto a moving object. The main photograph was taken by mounting the camera on a bicycle. At the bottom of the picture you can see the bicycle light, which is in focus, while the bright lines above are a result of the streetlights rushing past as I cycled through the streets.

You could do something similar by attaching your camera to any movable object such as a car, a skateboard, or even your shoe. Use tape, string, or rubber bands to hold the camera in place. If you really want to make sure it doesn't fall off you could even glue it in place—this will probably ruin the camera when you're finished, but you can always make another one!

Once your camera's attached, open the shutter. The exposure time at night will be in the region of 30 minutes to an hour to photograph light trails, so don't worry that the camera is exposing the film straight away.

Then start moving! It doesn't matter if you just cycle down your street or drive into town. but to get cool-looking light trails you need your camera to be in motion. When you reach your destination, replace the shutter and either detach the camera or wind it on to make a second exposure on the return journey.

ABOVE AND RIGHT: Light trails can make fantastic subjects on their own, but having something sharply focused in the frame adds to the sense of movement.

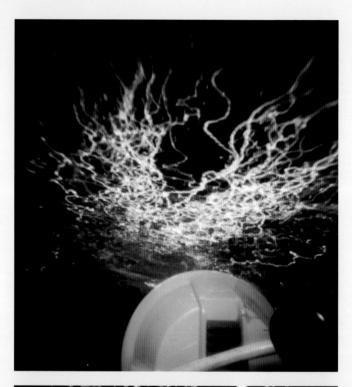

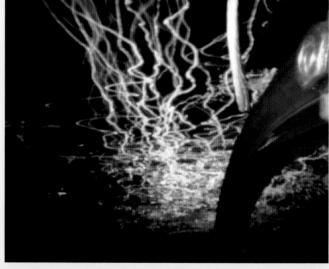

Project 4: A Worm's Eye View

Because there's no viewfinder to look through on a pinhole camera, and no LCD screen on the back, there's no reason why you have to take your pinhole pictures at eye level—so liberate yourself from your normal view of the world and drop the camera to the ground!

The strangeness of your "worm's eye" viewpoint will be emphasized by the pinhole camera's depth of field, with everything in front of the

lens coming out in focus; but don't just limit yourself to everyday scenes. Go crazy, and let your imagination run wild as you take photographs of an "alien" world. As soon as you do, you'll start to take unique pictures from a viewpoint that you will rarely experience for yourself.

ABOVE: This was taken at St. Paul's Learning Centre in Bristol, England. Pinhole is all about experimenting and getting creative, not rules!

ABOVE LEFT: A worm's eve view of the Empire State Building, with my hand in the foreground.

LEFT: Without any motors or a noisy shutter, your pinhole camera is perfect for taking "sneaky" closeup pictures!

Digital Pinhole

Although this book is about making and using your own paper pinhole cameras with 35mm film, we can't ignore the world of digital photography. At the very least you might want to scan your favorite shots so you can make enlarged prints on your home printer, upload them to a website, or simply email them to friends. But you can take digital pinhole further than this by using a pinhole lens on a digital (or film) SLR. In this chapter, we'll look at the options available, with some great makes and top tips for pinholing in the digital age.

Image © photographer Chris Gatcum.

Digital Pinhole Perfection

Before

If you want to share the pictures from your paper cameras with friends and family—or online—or make enlargements using your home printer, the first thing you need to do is get them onto your computer.

If you already have a scanner, you will probably know how it works already, but you don't need to have a scanner to get your pinhole pictures digitized. Most stores that process film will also be able to scan it at the same time at a relatively low cost. This saves you time doing it yourself so you can get straight on to making your shots look their best—as the following step-by-step guide explains.

Making Your Pinhole Pictures "Pop"

You can use any image-editing program to make the pictures from your paper cameras look great—whether it's Adobe Photoshop, Photoshop Elements, Corel Paintshop Pro, or another editing program. If you don't already have image-editing software on your computer then why not try Gimp? This program has all the editing features you need and, best of all, it's free!

Exposure and Contrast

If your exposure was a little off, then chances are your picture will be either too light or too dark. This is easily fixed using Levels (Image > Adjustments > Levels). When you call up the dialog, you will see a graph known as a "histogram." Underneath this are three sliders, which we'll use to fix the exposure:

- i) First, move the left (black) slider to the right a little-until it hits the end of the graph. This makes sure the blacks in the picture are black.
- ii) Then, move the right (white) slider to the left until it touches the end of the graph; this gives you nice bright whites.
- iii) Finally, use the middle slider to adjust the overall brightness (exposure) of the picture. Move it left to make the picture lighter, and right to make it darker. When you're happy with the way things look, click OK.

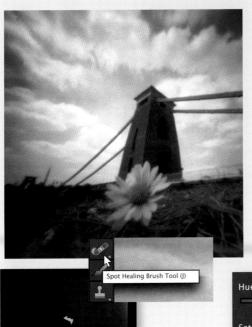

Dust and Scratches

After you have adjusted the contrast and exposure you might notice a few white specks on your picture. These are caused by small bits of dust sitting on the film when it was scanned, and it's something you want to get rid of.

Select the Zoom tool from the toolbar and zoom in to the picture so you can see the white dust marks easily. Then choose Photoshop's Smart Healing tool. Most programs have a similar tool, although it might have a different name.

Use the square bracket [] keys to adjust the size of the Healing tool so it roughly matches the dust mark, then click on it—your editing program will instantly zap the speck! Keep going until your picture is speck-free.

ABOVE, LEFT, AND BELOW: In three simple steps a fairly lifeless scan has been transformed into a picture that's perfect for printing or sharing with your friends.

Color

The long exposures that your paper cameras need often exceed the film's best working range. This can start to affect the color, and the most common problem is weak colors that lack vibrancy. To bring them back to life, use the Hue/Saturation control (Image > Adjustments > Hue/Saturation) in Photoshop.

i) The Hue slider adjusts the overall color balance. If you think your image looks too red or too green, or has too much yellow in it, for example, try adjusting the Hue slider to change the overall balance.

ii) The Saturation control affects the overall intensity of the colors. To intensify the color in your pinhole pictures, move the slider to the right. Don't be too heavy handed—an adjustment of between +10 and +25 is normally enough. Alternatively, move the saturation slider to the left, to -100, to quickly convert your picture to black and white.

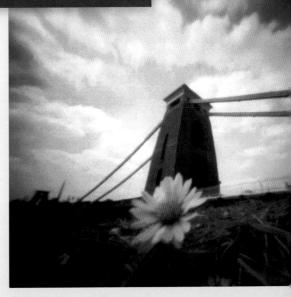

WHAT YOU NEED

- Body-cap for your SLR
- Pinhole lens (see page 20)
- Drill with ½-inch (12mm) bit
- Fine-grade emery paper
- Glue

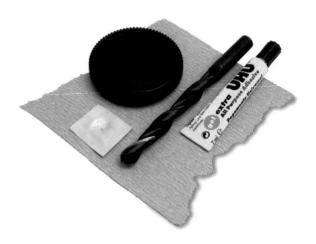

DSLR Pinhole Lens

If you own a digital SLR, you can take pinhole photography into the digital dimension by making your own "digital" pinhole lens. All you need is a homemade pinhole lens and an adaptor. Here's how to put the two together.

Making an SLR **Pinhole Lens**

The easiest way of making a pinhole lens for your SLR is to use a body-cap—the cap that you would put on the camera if you didn't have a lens attached. These can be bought for a very small amount from camera stores or on the internet.

There are several advantages to adapting a body-cap. For a start, it will fit onto your camera like a regular lens, making it easy to switch between the pinhole lens and your normal lens. The plastic body-cap is also durable, so it can be left in your camera bag without getting damaged. Finally, the thick black plastic and secure bayonet fit mean the lens will be light-tight, so taping the edges or sticking anything to your camera isn't necessary.

The first step is probably the hardest you need to find the exact center of the body-cap. The easy way to do this is to draw around the cap onto a piece of paper. Cut out the circle you've drawn and fold the paper into quarters.

Line the curved edge of the paper template against the edge of the body-cap and the "point" of the paper will show you the center of the cap. Mark the center point.

You now need to drill a hole in the center of the body-cap to mount your lens. Using a large drill bit (1/2-inch/12mm is good), CAREFULLY drill through the center of the cap.

Next, use your fine-grade emery paper (or a small, fine-toothed file) to tidy the edges of the hole and remove any plastic burrs.

Finally, glue your pinhole lens to the reverse of the body-cap, keeping the pinhole as central as you can.

Once the glue is dry, you're ready to fit the body-cap pinhole lens to your camera and start shooting. Turn the page to find out how.

Using Your SLR Pinhole Lens

All of today's digital SLRs are incredibly intelligent, with electrical connections in the camera body and lens making sure the two work well together. Your digital pinhole lens is nowhere near as sophisticated, so there are a few things you have to do before you can shoot.

The most common problem is finding your camera won't fire with the pinhole lens attached. If this happens, look in your camera's manual (or the camera's menu) for a "shoot without lens" option, or similar. This is often used for sensor cleaning and you need to make sure it's switched on so your camera can be triggered without a lens attached.

You will also discover that the viewfinder image will be very dark—perhaps so dark that you can't see anything through it at all. This is because you're looking through the tiny pinhole

lens, which doesn't let in much light. But it's not something to worry about—one of the joys of digital photography is the ability to review your pictures on the camera's LCD screen, so if anything's not quite right just take another shot!

The same applies to your exposures. Because there aren't any electrical connections between the camera and your pinhole lens, your camera might struggle to work out the exposure for itself, so set your camera to its Manual exposure mode (normally marked with an M on the mode dial) and use the exposure guides on pages 64-67 to set the shutter speed.

After you've taken your picture, review the image on your camera's LCD screen. If it's too dark. increase the exposure time or, if your first picture is too light, decrease the time and try again.

ABOVE: Image © photographer Chris Gatcum. Experiment with using the "wrong" white balance on your DSLR and moving your camera during the exposure. This abstract picture of a reed bed was taken in daylight with a tungsten white balance.

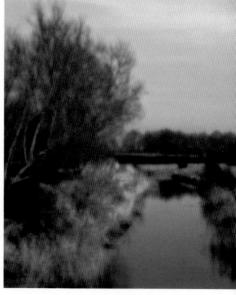

ABOVE: Image © photographer Chris Gatcum. A pinhole lens on a digital SLR will not produce images that are as sharply focused as a film-based pinhole camera, but the impressionistic results have a unique look to them.

Zero Cost Pinhole Lens

If you don't want to drill your camera's body-cap, don't have one spare, or simply don't want to buy one, you can make your pinhole lens mount out of thick card instead. It might not be as "neat" as a body-cap (or as durable, or as easy to remove), but it's just as functional and won't cost you a thing!

Draw around your camera's body-cap so you can cut a circle of card that matches the diameter of your DSLR's lens mount. Make a hole roughly ½-inch (12mm) in the center of the card disk-this doesn't need to be perfectly round, it's just so the lens can be mounted behind it.

Mount the pinhole lens plate on the side of the board that will be facing the camera's sensor (the side that will be "inside" the camera) using tape or glue.

Tape the lens panel to your camera using black tape. Make sure you go all the way around the edges to stop any light leaking in from the sides.

Using Digital Pinhole Cameras With Flash

First follow the "using flash" instructions on page 76, then give this a try! Although using a pinhole on the body-cap of a DSLR will not enable the pinhole to get close enough to the CCD for maximum sharpness, it will open up other worlds of undiscovered imaging, the most instant and effective of which is using flash.

Exposure

Many DSLRs have light-sensitive automation, which can handily compensate for electronic flash detection and exposure.

Set the camera on "B" and the electronic flash on full power. Position the flash at a close distance to the subject. Initially, try 50mm. Then set the flash off (pointing towards the subject rather than the pinhole) while the shutter is open, relying on the flash to give the exposure. Settings on individual cameras vary, but experimenting with a few test exposures will ensure successful results.

RIGHT: This flower was illuminated by multiple studio flashes to build up the exposure. The rest of the studio was in darkness.

Aiming

Due to the small size of the CCD, and the relative distance of the pinhole, it can be tricky to be sure what is in the field of view. When using a hand-held flash with digital, you can continually refer to the previous captured image and retake the picture if required.

This does result in a completely different "pinhole ethos" compared to film, allowing the ability to instantly view the final image—but digital hasn't taken over the world for nothing!

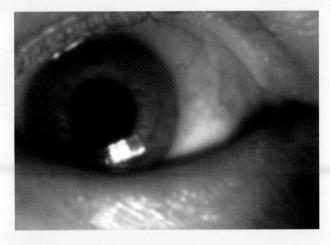

ABOVE: This was taken on an electronic flash with the DSLR on B setting.

Multiple Flash and Studio Use

When using a pinhole DSLR in the studio, it is possible to "mark out" the field of view by pointing a bright torch towards the camera, which can show the limit of the field of view in the viewfinder. If the camera is on a tripod it is possible to use multiple flashes to build up the exposure. You can also combine flash with ambient lighting; experiment with movement; and even break the DSLR taboo by taking multiple exposures.

ABOVE: This creepy image of teeth was taken using an electronic flash with the DSLR on a B setting.

Digital Pinhole Effect

We've seen how to make paper cameras and how to turn your SLR into a pinhole camera, but I'm sure there are some pictures on your hard drive that would look great as pinhole shots. So here's a great technique that you can use to give any of your digital pictures the pinhole feel. All you need is an image-editing program (and, of course, your picture), and in a few simple steps you can create stunning "fake" pinhole pictures. I'm using Photoshop, but you can recreate the effect in most image-editing programs.

Image © photographer Chris Gatcum.

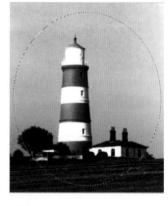

The image I'm starting with was shot in color, but because pinhole works so well in black and white, we're going to convert it using Image > Adjustments > Desaturate. This isn't the only way to convert a picture to black and white, but for this pinhole project it's perfect.

To replicate the slightly "fuzzy" look of pinhole pictures, I'll use Photoshop's Diffuse Glow filter (Filter > Distort > Diffuse Glow). The amount of glow you add is up to youcheck the Preview box and use the on-screen preview as a guide. Here, I used Graininess 10, Glow 11, and Clear 17 to give a slightly soft look with bright, diffused highlights.

Another common feature of pinhole pictures is dark edges, known as "vignetting." To recreate this in my picture I'll select the Elliptical Marquee tool from the toolbar and make an oval-shaped selection around the center of the frame as shown.

Next, I need to invert the selection (Select > Inverse) so the outer edges of the picture are selected, rather than the center. Also, the light fall-off needs to be gradual, so I need to soften the selection by going to Select > Modify > Feather. Use a high amount to make the effect gradual-I used 250 pixels for this picture.

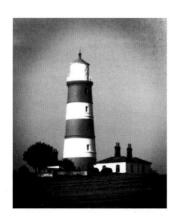

The picture's looking pretty good, but the edges look too sharp—I want them slightly softer to add to the pinhole effect. As the vignetted edges are still selected, all I need to do is choose the Gaussian Blur filter (Filter > Blur > Gaussian Blur). As with the darkening, keep the amount of blurring subtle.

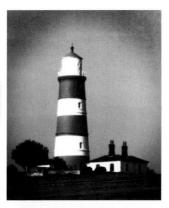

To darken the selected area. I'm going to use Brightness (Image > Adjustments > Brightness/ Contrast). Don't be too heavyhanded—you just want to make the edges slightly darker, not turn them black! With this image, a setting of -100 added a nice vignette.

The pinhole effect is finished, so you can save your image. Alternatively, you can tone it to give it a more traditional feel. To adjust the color, use Hue/ Saturation (Image > Adjustments > Hue/Saturation). Check the Colorize box and use the Hue slider to change the color. Moving the Saturation slider to the left will decrease the intensity of the color.

Further Information

Typing "pinhole photography" into a search engine will uncover thousands of sites on the subject, but here are some of my favorites:

Pinhole Cameras, Guides, and References

www.pinholephotography.org
www.home.online.no/~gjon/pinhole.htm
www.alternativephotography.com
www.f295.org
www.lomography.com
www.mrpinhole.com
www.pinholeday.org
www.pinholersource.com
www.pinholesolutions.co.uk
www.rednotebook.org/pics/pinhole/index.html
www.rraz.ca/pin/pinhole.html
www.zeroimage.com

Jo Babcock www.jobabcock.com Thomas Bachler www.thomasbachler.de Pinky Bass www.wikipedia.org/wiki/Pinky_Bass Kenny Bean www.kennybean.co.uk Wayne Martin Belger www.boyofblue.com Jay Bender www.jaybender.com Dianne Bos www.diannebos.ca Celeste Brignac www.celestebrignac.com Valerie Burke www.valerieburke.artspan.com Martha Casanave www.marthacasanave.com Katie Cooke www.slowlight.net Heidi Crabbe www.pinhole-photographer.co.uk Walter Crump www.waltercrump.com Bethany de Forest www.pinhole.nl Kathryn Faulkner www.kathrynfaulkner.com Paolo Gioli www.paologioli.it Guy Glorieux www3.sympatico.ca/guy.glorieux Adrian Hanft www.foundphotography.com Jamie House www.jhouse78.wordpress.com Steve Irvine www.steveirvine.com Gregg Kemp www.greggkemp.com Edward Levinson www.edophoto.com Robert Charles Mann www.thencamenow.com/photo Abelardo Morell www.abelardomorell.net Marja Pirila www.marjapirila.com Justin Quinnell www.pinholephotography.org Willie Anne Wright www.willieannewright.com

Worldwide Pinhole Photography Day

At the beginning of this century, a few enthusiastic volunteers had the idea to promote pinhole photography on a global scale. As a result, on April 29, 2001, a total of 291 people from 24 countries each took a pinhole photograph, and within a month had loaded them onto the Worldwide Pinhole Photography Day website.

The annual event now attracts thousands of people from all over the world, who spend the last Sunday in April discovering—and, most importantly, sharing—the wonder of pinhole photography.

Getting involved in Worldwide Pinhole Photography Day is simple—just follow these steps:

- 1. Make a pinhole camera.
- 2. On the day, take some pinhole photographs.
- 3. Get your film developed and upload your favorite image to the Worldwide Pinhole Photography Day website (www.pinholeday. org) before the end of May.

As well as the gallery of images, the website contains information on events happening around the world, along with resources that enable as many people as possible to be part of the day.

A quick look at some of the thousands of images on the Worldwide Photography Pinhole Day gallery will give you an idea of the liberated approach people have. Even without the complexities of modern pinhole technology, things happen!

Index

adhesives 19 angle of view 70

black-and-white photography 58–61 blur 71 brightness 84

camera capes 25, 63
camera obscura 7, 22–3
Cameras folder 10
card 18, 24
Chompy 44–7
chromogenic film 59
close-ups 74–5
color adjustment 85
color photography 54–7
Color templates 11, 12–13, 19
contrast adjustment 84
costs 9
cutting 18

depth of field 9, 71, 75 digital pinhole effect 92–3 digital pinhole lenses 86–9 with flash 90–1 dust 85

exposure 9, 64–7 exposure adjustment 84 Exposure Guide 10

faster film speeds 67 film 54, 56 film speed 55, 58, 64–7 flash 72, 76–7, 90–1 focus 9 folding 19 ghosts 73 Gimp 11, 14, 84 glues 19 grain filters 60

history 6–7 Holeiflex 30–3

image-editing 11, 84–5 digital pinhole effect 92–3 infrared (IR) film 60 ISO 55, 58, 64–7

landscapes 70–1 lenses 7, 20–1, 22, 86–9 License Agreement 10 light trails 80 Like-A 17, 24–5 Line Art templates 11, 14–15, 19 loading film 62–3 long exposures 64

movement 71 multiple exposures 9

negatives 54,56 night photography 80

overexposure 65

PDFs 11
perspective 71
pinhole effects 92–3
Pinhole Resource Center 8
Pinolta 26–9
Pinox 34–7
portraits 72–3,79
printer drivers 13

printing 12–13 processing 9, 56, 58–9, 84 push processing 59

reciprocity failure 66 rewinding 69

saturation 85 scanning 56, 60, 84 scratches 85 self portraits 79 shutters 25, 63, 68–9 slide film 56 slow film speeds 66 SLR pinhole lens 86–9 Stencil Cam 48–51 still-life 74–5

take-up spools 62–3,69 templates see Color templates; Line Art templates texture 60 Thrillium Fox Holebot 38–43 transparency film 56 tungsten film 56

underexposure 65 uprating film 59

white balance 86 windshield squirter 78 worm's eye view 70, 81

Acknowledgments

Acknowledgments

This book is for Chrissy, Louis, Rosa, and everyone inspired by wonder.

Pinhole photography creates more ideas than we have time to explore them. In our increasingly screen-based world, our Auto buttons replace accidents and our gadgets are pre-programmed with answers before we get a chance to dream up our questions. But through all of this technological advancement, it is heartening that so much joy can come out of something so simple.

Let us hope this magic will continue to be uncovered for generations to come, as long as light travels in a straight line and people have the time to seek out inspiration.

Justin Ouinnell www.pinholephotography.org

Pic Credits

All pinhole photographs by Justin Quinnell, with the exception of those listed below.

Dianne Bos: www.diannebos.ca p52.

Corbis: www.corbisimages.com

Chris Gatcum: www.cgphoto.co.uk p18-21; p68-69; p73 (bottom right); p82; p86-87; p88 (all); p89 (all); p92-93.

iStock: www.istockphoto.com p59 (top right).